IMAGES
of America

LATHROP

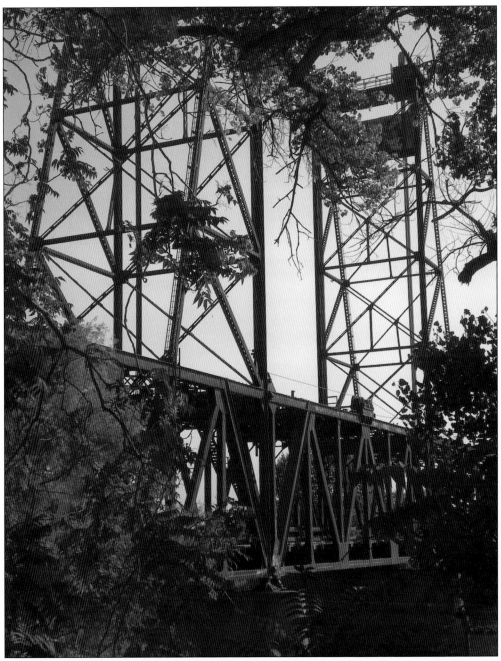

Located at Mossdale, the current railroad bridge over the San Joaquin River is a double-track lift span. In this view of the bridge, Tracy is toward the left and Lathrop is toward the right. (Author's collection.)

ON THE COVER: The gentlemen and lovely lady seen here look relaxed and content, as they pose outside a barracks at the Sharpe depot. Although there are a few military personnel in the group, most are in civilian clothes and seem to be visiting the depot that day. (Courtesy of San Joaquin County Historical Society and Museum.)

IMAGES
of America

LATHROP

Jennifer Pyron
Foreword by Mac Freeman

ARCADIA
PUBLISHING

Published by Arcadia Publishing
Charleston, South Carolina

Printed in the United States of America

Library of Congress Control Number: 2009934030

For all general information contact Arcadia Publishing at:
Telephone 843-853-2070
Fax 843-853-0044
E-mail sales@arcadiapublishing.com
For customer service and orders:
Toll-Free 1-888-313-2665

Visit us on the Internet at www.arcadiapublishing.com

*This book is dedicated to my family, who
supported me throughout its writing.*

CONTENTS

FOREWORD

When Jennifer Pyron asked me to write the foreword to this book, I was honored, as she has done a superb job of chronicling the history of my beloved hometown. At last, here is a history of Lathrop in book form. It has been said that "a picture is worth a thousand words," and this pictorial history book tells the story from the start to the present. Rather than giving prominence to the founder of Lathrop, I like to emphasize the individual people and families who started, worked, built, and persevered, generation after generation, in and around Lathrop. The only reason Leland Stanford bought Wilson's Station and founded Lathrop was to continue building his fortune. He first tried to talk the Stockton City Council into allowing him to build his railroad down the middle of El Dorado Street. They refused, and the rest is "Lathrop's history."

I would like to recognize the families who started Lathrop, who, within a few years, increased the population to 1,500. Families came from all over the country and the world to live and thrive here. After 1886, when the roundhouse was moved to Tracy, Lathrop's population fluctuated. Further compounding the problem was the economic downturn associated with the depression of 1929. Jobs were created in Lathrop when Sharpe Army Depot was built in the 1940s, Best Fertilizer opened in 1952, and later Libby-Owens Ford glass was established. When I moved here in 1951, the population of Lathrop was about 900. In 1989, when Lathrop was incorporated, the population had increased to 5,140. Twenty years later, Lathrop's population is around 18,000.

Many of the families of Lathropeans from the 1870s through several decades were instrumental in building the town as it is today. A large number of their descendants still either live here or in the surrounding areas. Many of the families who at one time lived in town but now live in other parts of the United States still remember Lathrop fondly and stay in touch with those of us who are still here.

—Mac Freeman
former mayor of Lathrop

Acknowledgments

I would like to thank everyone who so graciously contributed to this project. For their time and assistance in the research and putting together of this book, I would like to extend my appreciation to Arcadia Publishing and John Poultney, my editor, for patiently helping me through the process. My thanks go to the following residents of Lathrop, professionals, and institutions for granting me access to their collections of photographs and information and offering their knowledge of Lathrop to assist me in this work, especially Mac Freeman; Roy Tinnin; Susan Dell'Osso; Lathrop mayor Kristy Sayles; David Silveria; Diane Hirata; Margaret Luevano; Arnita Montiel; Bennie and Joyce Gatto; Ralph Lea of Lodi; Gary Kinst, Larry Mullaly, and Kevin Hecteman for their railroad expertise; Cara Randall and the California State Railroad Museum; Bill Maxwell and the Bank of Stockton Archives; Leigh Johnsen and the San Joaquin County Historical Museum; Debbie Cismowski at the Caltrans Library in Sacramento; the Manteca Unified School District; the Bancroft Library at the University of California, Berkeley; Mike Wurtz and the University of the Pacific archives; Stacy Mueller and the California Room at the San Jose Public Library; and many others not named here.

Finally, this book would not have been possible without the support of my family and friends, especially my husband, Justin Pyron. Thank you for your love, patience, and confidence in me while I researched and wrote this book. My sincere gratitude goes to my mother, Peggy Maurer, for her encouragement, for assistance in editing, and for babysitting my young children so I could go research. Last but certainly not least, I must thank my children, Amber and Tristan Pyron, who patiently accompanied me on various excursions in the researching and assembling of this book. I hope when you are grown you remember where you grew up and are proud to share its history.

INTRODUCTION

The area now known as Lathrop was first called Wilson's Station, named for Thomas A. Wilson, who opened the La Barron and Company store in French Camp in 1849. However, the first inhabitants of the area were the Yokut Indians, who used the Mossdale area (in west Lathrop) as a river crossing and fishing spot. The area around the San Joaquin River was lush with willow and oak trees and was a popular spot for hunting, fishing, and trapping otter and beaver. By 1833, the Yokut Indian population was mostly gone, having died of cholera and malaria. The fall of 1846 brought 30 Mormon pioneers, who landed on the east bank of the river at Mossdale near where the railroad crossing is today. These pioneers arrived on the sailing vessel Comet and then continued up river to establish New Hope, a colony near the junction of the San Joaquin and Stanislaus Rivers. In November 1848, John Doak and Jacob Bonsell established the first ferry on the San Joaquin River at Mossdale. After Bonsell's death in 1852, his wife and her new husband, Maj. James Albert Shephard, ran the ferry. Shephard sold the ferry in 1856 to pioneer William Simms Moss and his son William B. Moss Jr. The elder Moss invested heavily in land in the Lathrop area. He came to own much of the land between the ferry at Mossdale and the current port of Stockton. His ferry business was a financial success. Once the railroad came into action, there was little need for the ferry, but Moss allowed the Western Pacific Railroad the right-of-way along the eastern edge of portions of his land. Western Pacific ended up bankrupt before even starting the project, but the assets went to the Central Pacific Railroad. The elder Moss sold the right-of-way to them for $2,100 and then went on to establish the *San Francisco Examiner* newspaper.

Other early pioneers to the area arriving in the 1850s included the Reynolds family, Alvin Shed, Henry Moore, and Humphrey Sherman Howland. At the time of their arrival and shortly thereafter, there was not much in the way of a town. It was mainly some shops surrounded by the ranches of the local farmers. It was not until after Leland Stanford's influence brought the railroad to this quiet hamlet that the structure of streets and neighborhoods was implemented.

The heart of Lathrop's story begins in the late 1860s and early 1870s, when it began as a railroad "canvas town." The town grew, and the canvas tents were replaced by more permanent wooden buildings. Stanford, the eighth governor of California from 1862 to 1863 and one of the "big four" partners of the Central Pacific Railroad, was the instrument behind the establishment of the railroad in Lathrop. He also built a large hotel and restaurant downtown. The town was named by Stanford in 1869, most likely after his wife, Jane Lathrop, and her family. That year also saw a historic moment for the railroad in Lathrop with the completion of the nearby San Joaquin River railroad bridge. This last link of the Transcontinental Railroad in California completed the rail connection of the East Coast with the West Coast at Oakland/San Francisco. Construction proceeded simultaneously in each direction, from Sacramento and from the bay area, meeting in Lathrop at the San Joaquin River. The first train crossed the bridge on November 10, 1869. As the San Joaquin Valley headquarters for Central Pacific Railroad (now the Union Pacific Railroad), Lathrop was a division point where they switched and made up trains. Because of its crossroads location, the town had a 12-engine roundhouse used for the repair and rebuilding of the railroad engines. Lathrop's post office was established in 1875. However, destruction came upon the town in 1886 when fire burned much of the downtown area, including the train depot and terminal.

Railroad operations were largely moved to Tracy then, although Stanford threatened to move operations back to Lathrop whenever conflict arose between Tracy and the railroad. He never did follow through, but in 1891 the Southern Pacific Railroad constructed a new depot at Lathrop to replace the one that burned.

Perhaps one of the most interesting facts of Lathrop's history is the murder of former California court justice David S. Terry, which occurred here in August 1889. Terry was shot by U.S. Marshal David Neagle, bodyguard to Justice Stephen Field.

Refugees of the 1906 San Francisco earthquake sought temporary housing in the Lathrop area. They came by rail and stayed in homes or tents along the tracks until they were able to find permanent housing. In the 1930s and 1940s, tents in areas of Lathrop were occupied by Mexican migrant workers. The tents were replaced by wood cabins around 1950.

During the 1930s, the Mossdale area of Lathrop had amenities of its own, including a tavern, a school, a store, and an automobile repair garage. Eventually Mossdale School was sold to Grace Baptist Church in Tracy, and the children who remained went to Lathrop School. The garage in Mossdale was owned by Charles Abersold and Salvador Mauro. Abersold made the area his home in November 1904 when he came to Lathrop from Ohio. He moved here in the footsteps of his brother Christian, who came to California 10 years earlier. Abersold's partner, Salvador Mauro, also had family in the vicinity. Rosario Mauro owned 20 acres of land near the Mossdale Bridge. When he purchased the acreage, it was an expanse of tule marsh, but over time and with much hard work, he turned it into usable and profitable farmland. Somewhat earlier in 1918, Stuart Moore built block dairy barns to house his farm. At one time, Moore's dairy farm was one of the largest in the United States.

The early 1940s saw the beginning of industry being introduced in town. In 1942, Sharpe Army Depot was officially dedicated and went on to be used extensively during World War II, the Korean War, and the Southeast Asia conflict. In 1992, Sharpe Army Depot was still one of the county's largest employers and the western distribution center of repair and spare parts for the army. In the early 1950s, Best Fertilizer and Libby-Owens Ford glass company also opened facilities in Lathrop.

Over the years, Lathrop has grown to be a bustling community of approximately 20,000 residents. There are now shops, a big box store, parks, and an expanse of new homes to the west of California Interstate 5. Lathrop's boundaries have expanded, but one thing that has not changed is the community's pride in its town and its history.

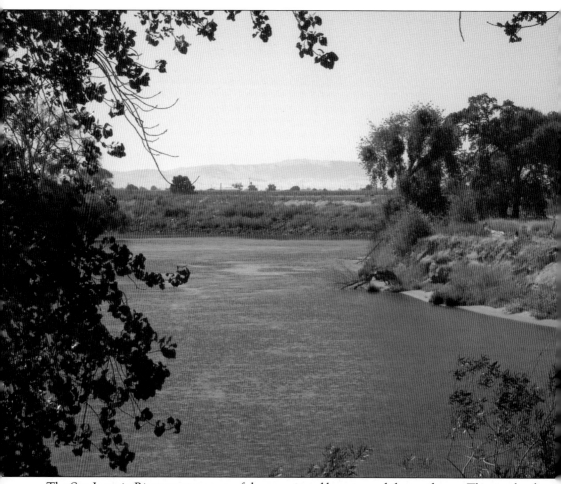

The San Joaquin River creates a peaceful scene viewed here toward the southwest. The riverbank on the right is Upper Roberts Island. (Author's collection.)

One

RAILROAD DAYS

Lathrop's past is rich in railroad history. The Southern Pacific Railroad was formed in 1865 and was acquired in 1868 by the same financial interests that were creating the Central Pacific Railroad. Central Pacific completed its hotel and restaurant in Lathrop on May 10, 1871. By this time, Lathrop was a major railroad stop, as trains met here from the north, the south, the east, and San Francisco in the west. It also became an important shipping point for produce to the San Francisco Bay area. Lathrop's railroad wye, tracks laid in a Y shape used to reverse the direction of a train, was said to be the biggest one west of the Mississippi River and the largest in California. Perhaps Lathrop's biggest claim to fame in regards to the railroad is the trestle bridge built at Mossdale over the San Joaquin River. This bridge was the true last link in the Transcontinental Railroad. Construction of the tracks started simultaneously in the San Francisco Bay area and Sacramento and met here at the San Joaquin River. The first train ran on September 10, 1869, but for a couple months, folks traveled until Mossdale, unloaded their luggage, and crossed the San Joaquin River by ferryboat before boarding another train on the other side. This piece of the journey ended when the Southern Pacific Bridge, as it was known for many years, was formally opened on November 10, 1869, thus completing the Transcontinental Railroad. The railroad was the heart of Lathrop for a long while and built the town up in its early years.

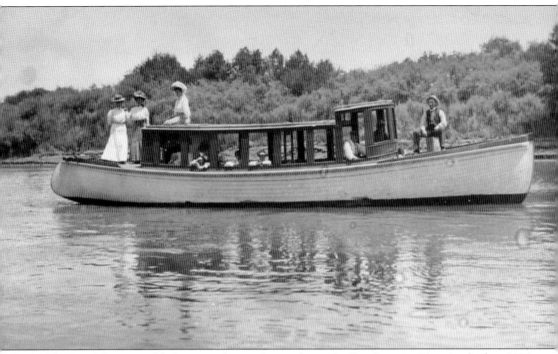

These gentleman and ladies are taking a ferry ride on the San Joaquin River in the late 1800s. At the back of the boat are three lovely ladies enjoying the scenery in their becoming hats. The infant peering out the first window on the left seems calmed by the smooth waters. In the early days, there were passenger boats up and down the river and out to the islands. In November 1848, John Doak and Jacob Bonsell built the first ferry in the county and on the river. At first, they charged $1 per person to cross. After building a larger boat, they raised their rates to $3 for a man and a horse and $8 for a wagon, but it was still $1 for a single person. The ferry did well, bringing in almost $1,000 a day for a while. Beginning in 1869, the Bonsell ferry was used by railroad passengers to cross the river to another train. (Courtesy of Mac Freeman.)

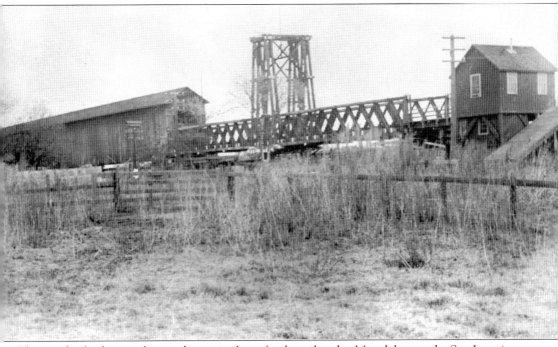

The wooden bridge seen here is the original one for the railroad at Mossdale over the San Joaquin River. It was built in 1869. The first train from Boston passed over the bridge on its way to San Francisco on May 22, 1870. The bridge was built with a lift span so boats could go as far as San Joaquin City, 8 miles up river. The Bank of Stockton Archives notes, "The wooden tower rested upon a turntable that swung the adjacent sections of bridge deck parallel to the banks of the river so steamers could pass by. The remaining portion of the span was one of only two covered bridges to be constructed in San Joaquin County." Farmers came to turn the bridge by hand whenever they heard a ship's horn blow to announce its arrival. This original bridge was replaced by an iron truss bridge in 1895. (Courtesy of Bank of Stockton Archives.)

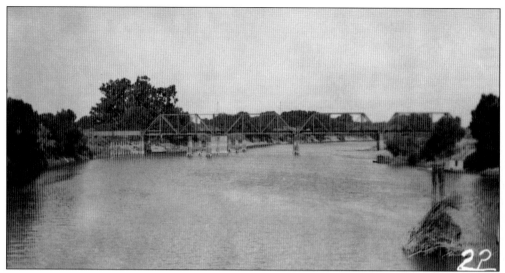

The second bridge built over the San Joaquin River at Mossdale is shown here from the Tracy end of the span. This single-track structure was built by the Phoenix Bridge Company of Pennsylvania in 1895. Traffic began to cross it on January 6, 1896. Williard Buzzell of Mossdale became the tower foreman of this bridge on May 16, 1907. (Courtesy of California State Railroad Museum.)

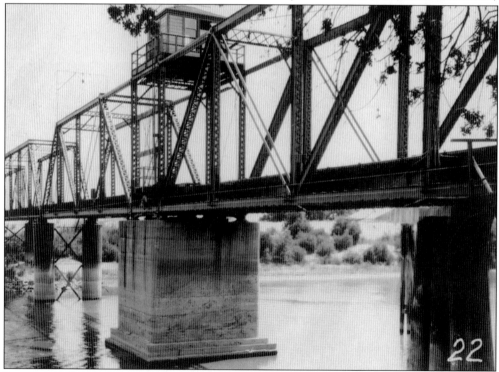

Between 1935 and 1940, the San Joaquin River was so shallow that boats could not travel it, and at some point during this time the lift span was permanently welded to the rest of the bridge. The substructure of the bridge consisted of cast-iron cylinders filled with concrete and pivot piers, all on piles. This bridge was replaced by the current one in 1944. (Courtesy of California State Railroad Museum.)

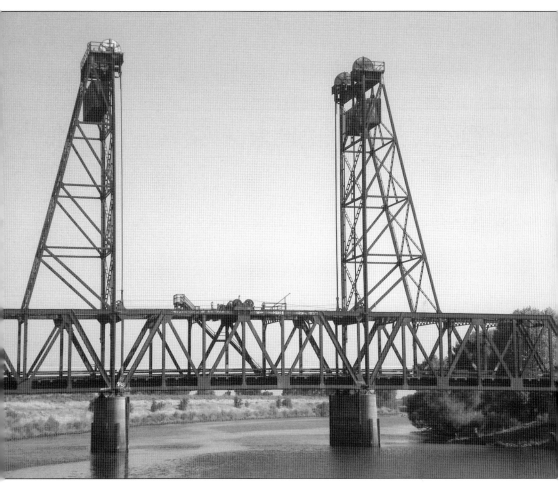

Over time, the railroad bridge at Mossdale was again replaced with a new structure. Built in 1944, the majestic railroad bridge pictured here is the third one to span the San Joaquin River at Mossdale. It is a double track, steel bridge with a vertical lift. This impressive bridge is crossed by freight trains today, as local fishermen try their luck angling on the banks of the river below. Seen for miles around, the bridge is a popular historical place for photographs. The Internet has many references to this spot and is full of photographs of this bridge by many a photographer, amateur and professional alike. Although the time of the original bridge spanning this river is long past, the landmark bridge is a symbol of a time when the hustle and bustle of Lathrop revolved around the trains. (Author's collection.)

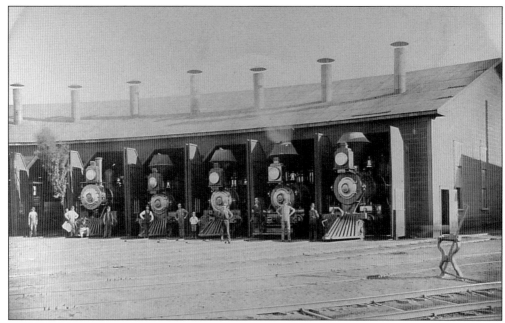

The railroad roundhouse at Lathrop, shown here in the spring of 1891, had a total of 12 compartments. It was located near McKinley Avenue across the tracks from Seventh Street. The second locomotive from the right has running boards instead of a cow catcher. This locomotive was used for switching cars in the rail yard, with the switchmen standing on the running boards. (Courtesy of Roy Tinnin.)

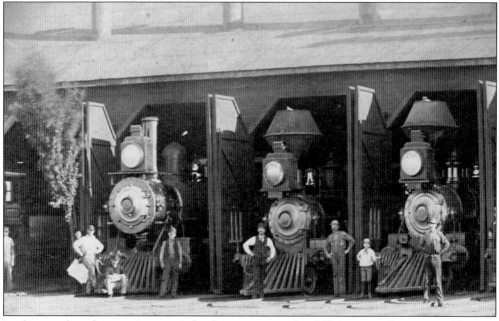

Looking at these locomotives more closely, one can see the differences in the engines. The two engines on the right have wider smokestacks, indicating that they were wood-burning locomotives. The narrow smokestack of the engine on the left indicates it was a coal-burning locomotive. (Courtesy of Roy Tinnin.)

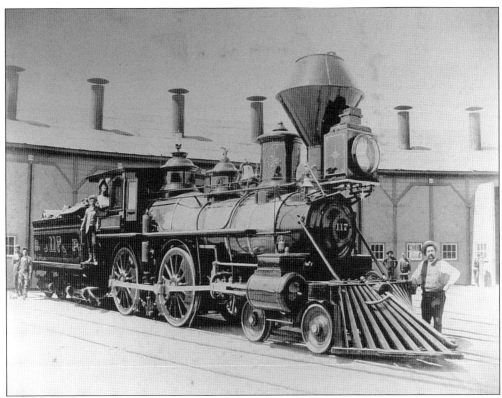

Pictured at the Lathrop roundhouse in the late 1800s, locomotive No. 117 was a wood-burning locomotive. The fresh coat of paint indicates it had recently been restored at the Southern Pacific Railroad's shops in Sacramento. The engine has some flourishes painted near the smokestack and a star dangling from under the headlight. The car directly behind the locomotive is the tender used for carrying fuel and water. (Courtesy of Roy Tinnin.)

Locomotive No. 1408 is Frank Smith's "mill," built in 1888. Although this local train has only two cars, it has a full complement of well-attired trainmen, including a conductor, two brakemen, and a baggage man. Locomotive 1408 ran on oil, as noticeable by the tank in the tender car behind the engine. This photograph was taken in 1898 by H. E. Plummer. (Courtesy of Roy Tinnin.)

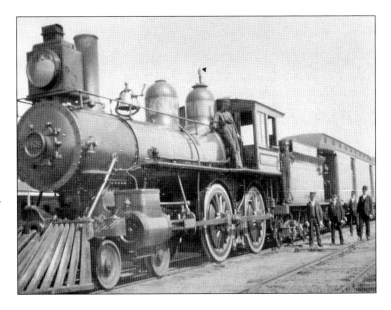

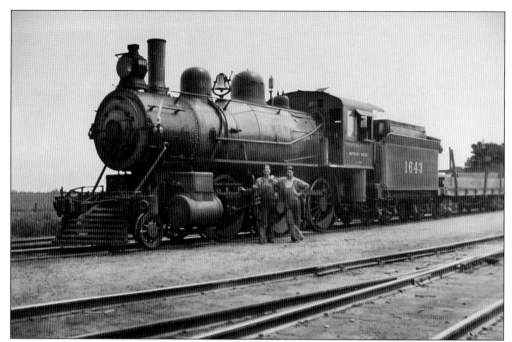

Southern Pacific Railroad engine No. 1643 is pictured here with two crewmen. It was a coal-burning locomotive built in 1900. By the time of this photograph, it had been refurbished to run on oil. The crewmen of this handsome mogul locomotive capture the camaraderie of a time in which all trainmen belonged to railroad lodges, and becoming a locomotive engineer was the dream of every boy. (Courtesy of Roy Tinnin.)

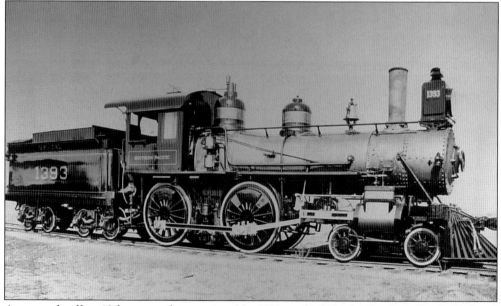

An example of late-19th-century locomotives, No. 1393 was built for the Southern Pacific Railroad in 1888 by Rogers Locomotive Works. The narrow smokestack indicates this was a coal-burning locomotive that had been converted to oil fuel. It was used for light freight duties around Lathrop until it was scrapped in Los Angeles in March 1925. (Courtesy of Roy Tinnin.)

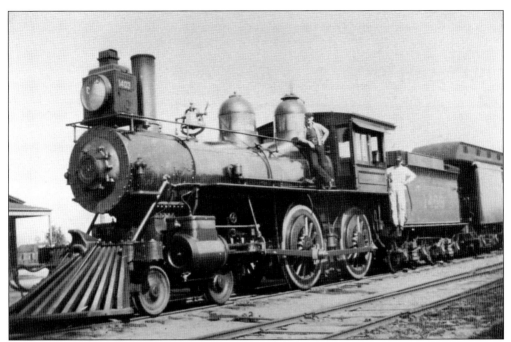

This coal-burning engine, No. 1403, sits at the depot ready for its next passengers. The engineer (left) and fireman stand on the train. The advent of oil fuel on Southern Pacific Railroad engines between 1900 and 1910 marked a change for firemen, whose job with coal burners depended on a shovel and muscle power. The wooden cowcatcher indicates this was an older style of engine. (Courtesy of Roy Tinnin.)

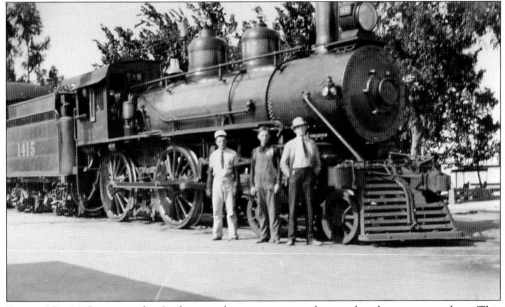

Engine No. 1415 is stopped at Lathrop with its engineer and a couple other crew members. This locomotive was built in 1887, and at the time of this photograph it was running on oil. The pilot or cowcatcher at the front of the engine is from the late 1890s or early 1900s. This locomotive was retired from service in 1910. (Courtesy of Roy Tinnin.)

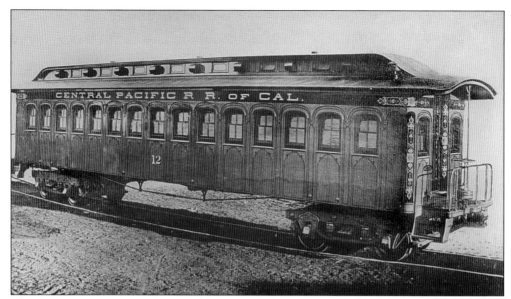

This was a typical passenger car between the 1860s and the 1880s on Central Pacific Railroad lines. It had wooden shutters to darken the car and wooden seats. At each end of the car was a wood stove to warm it. This particular car, No. 12, was built by Wason Manufacturing in 1864. The coach came to California by sailing a ship around South America. (Courtesy of Roy Tinnin.)

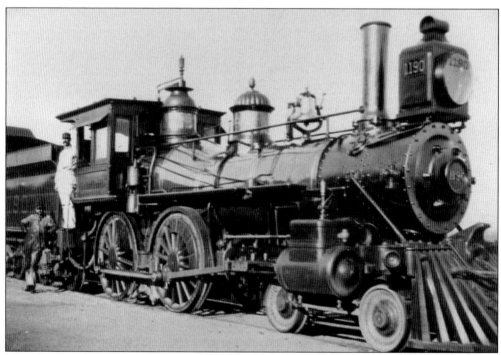

This photograph, taken in 1898, shows engine No. 1190. The majestic locomotive was built by San Francisco's Union Iron Works for the Transcontinental Railroad in 1865. Originally designed to burn wood, the locomotive was converted to coal and around 1905 changed once again to use oil fuel. (Courtesy of Roy Tinnin.)

20

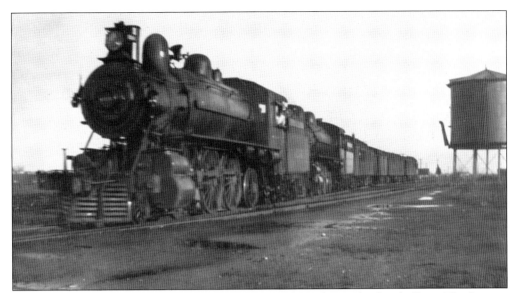

Having just passed the water tank, the engineer is watching the tracks ahead of him. The fireman aboard the train was the one to use the water tower to fill the train's water tank. Using the tower built alongside the tracks, the fireman positioned its arm over the train's tank and then pulled a rope, which released the water into the train. (Courtesy of Roy Tinnin.)

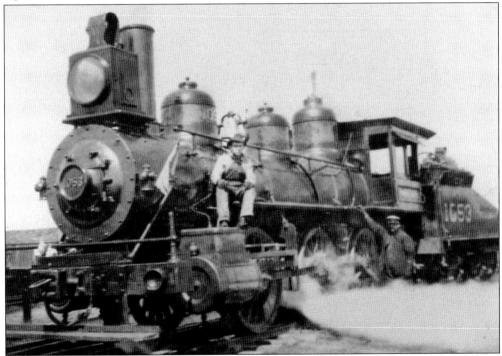

Steam locomotives were notoriously long-lived trains. This engine, No. 1053, had originally been built for freight service on the Central Pacific Railroad lines in 1876. Twenty years later, the engine was shorn of its front wheels and transfigured into switching service. The presence of coal in the tender indicates that the photograph was most likely taken some time before 1905. (Courtesy of Roy Tinnin.)

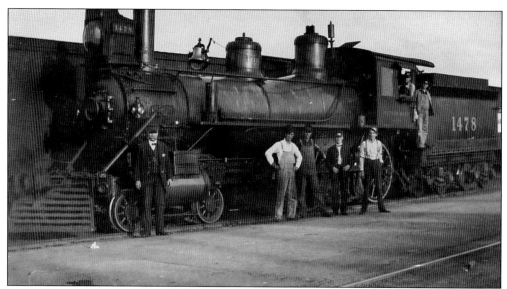

This railroad crew is posed in front of locomotive No. 1478, a coal-burning engine. Like many other locomotives in the early 1900s, engine No. 1478 had been converted to run on oil fuel. Around 1840, railroad bells became standard on locomotives. They were rung as a warning to those around of the oncoming train. The fireman, standing behind the engineer, was in charge of ringing the bell. (Courtesy of Roy Tinnin.)

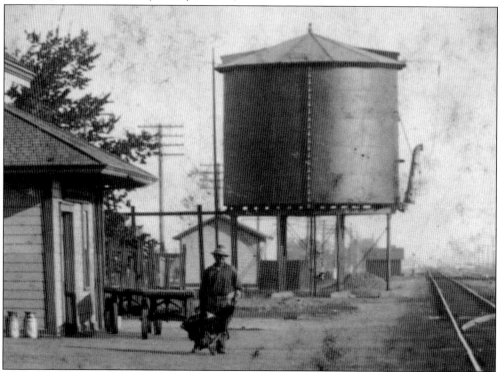

The water tank at Lathrop, shown here prior to 1906, may have held as much as 65,000 gallons of water. The buildings in the background are toolsheds for the railroad. A well-known event that took place in 1906 left the water tower in ruins. (Courtesy of Roy Tinnin.)

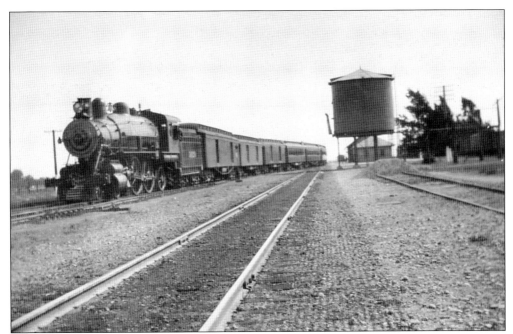

Around 1890, there were approximately 500 railroad hands residing in the town of Lathrop. Twelve passenger trains, one of which is pictured here, and 44 freight trains arrived at or passed through the Lathrop station daily. The switch engine was busy day and night. The sound of the train whistles can still be heard, as trains continue to pass through Lathrop regularly. (Courtesy of Roy Tinnin.)

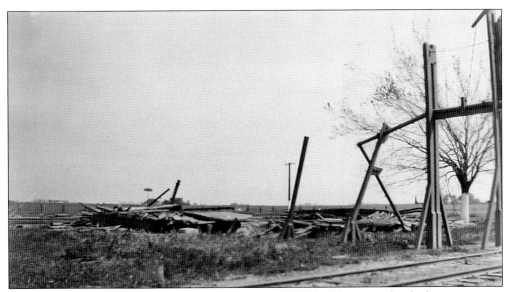

The water tank collapsed during the 1906 San Francisco earthquake. It was first built atop cast-iron pillars, and short blocks were later added between the tank and the pillars after advancements in locomotives made the engines taller. The collapse of the tank was not due to the force of the earthquake's movement but instead was a result of the swaying 200 tons of water on this unsteady construction. (Courtesy of Roy Tinnin.)

In 1875, the advertised local passenger tariffs on the Central Pacific Railroad were $3.50 from Lathrop to San Francisco. The longer the rail lines had gotten the more important Lathrop had become. For example, it was a transfer point from southern California to the East Coast. Travelers came north to Lathrop to go east to New York and Boston. (Courtesy of Roy Tinnin.)

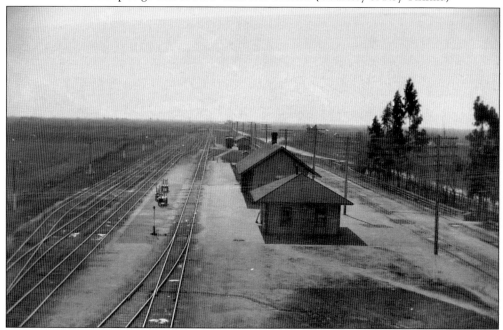

The Lathrop depot, shown here from the water tower, was located on the Seventh Street side of the tracks across from M Street. The building in the foreground is the Wells Fargo and Company Express office. The row of eucalyptus trees on the right side of the photograph is still standing today. Seventh Street is visible just past the trees. (Courtesy of Roy Tinnin.)

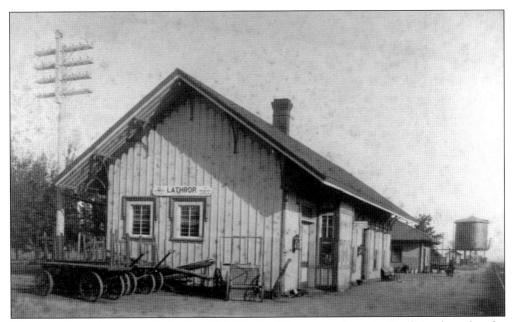

This is Lathrop depot as it looked in 1913. The building was a depot in Stockton, but after the hotel fire in Lathrop around 1892, this building was cut up and moved to Lathrop on six flat cars, where it was then reassembled. To the left of the depot is a telegraph pole. (Courtesy of Roy Tinnin.)

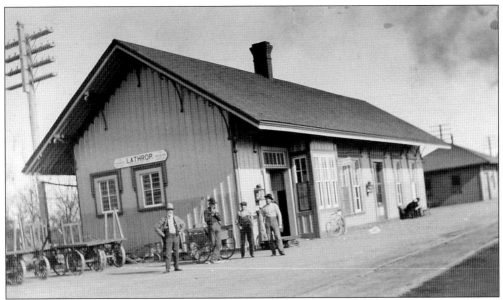

Before becoming the town of Lathrop, it was listed on the railroad maps as Wilson's Station. Leland Stanford shifted his railroad building efforts here when he got frustrated with his unsuccessful attempts at getting a right-of-way in Stockton. A competitive man, he focused on Wilson's Station and renamed it Lathrop around 1869. The name was likely taken from the family of his wife, Jane Lathrop. (Courtesy of Mac Freeman.)

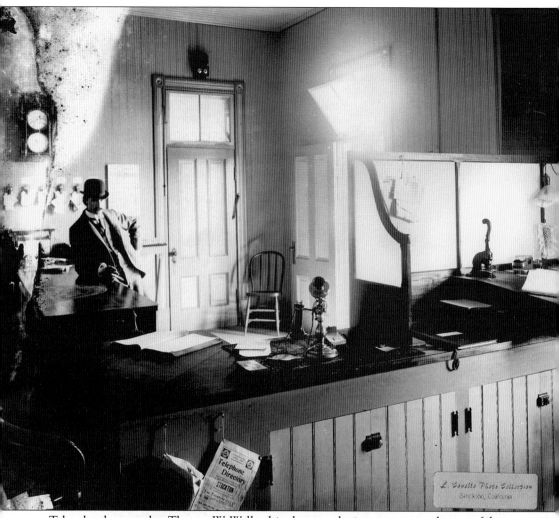

Taken by photographer Thomas W. Wells, this photograph gives a very rare glimpse of the interior of the Lathrop train station. The dapper-looking gentleman in the derby hat at the counter adds to the sense of the past in this photograph. Hanging from the front counter is a Stockton telephone directory for April 1900. One can just imagine the business of the depot when the town was the center of railroad lines and transfers. The now-antique clock on the wall would have helped the station agent to keep track of the train arrivals and departures. On the counter in the foreground is a non-dial, candlestick desk phone, and on the desk next to it is a small day-to-day calendar. At the far right behind the partition, a lamp is rigged for the desk there that is full of record books and other supplies necessary to a train depot. (Courtesy of Bank of Stockton Archives.)

Leland Stanford was at the forefront of Lathrop's establishment with the railroad. He was the eighth governor of California and one of the head runners of the Central Pacific Railroad. Stanford owned the San Joaquin Valley Railroad in 1870 from Lathrop to the Stanislaus River. This railroad was then consolidated with several others to form the Central Pacific Railroad on June 23, 1870. (Courtesy of California Room, San Jose Public Library.)

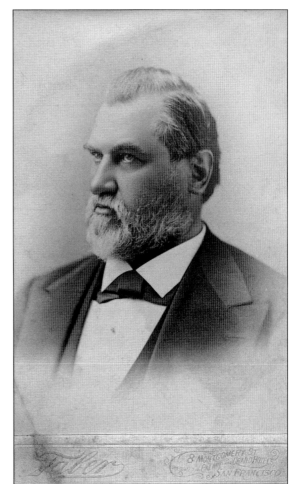

The Wells Fargo and Company Express was one of several buildings along the tracks at Lathrop depot. The cart near the doorway is ready and waiting with three cans of cream and several boxes. To the left of the cream cans is a strong box, a sturdily made box used for transporting money or valuables on the rails. (Courtesy of Roy Tinnin.)

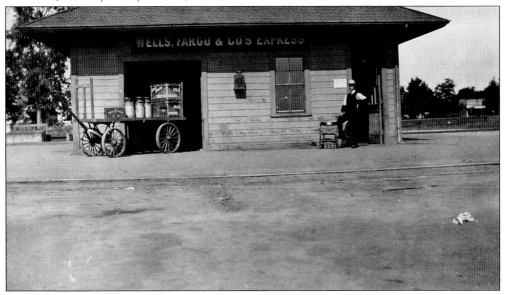

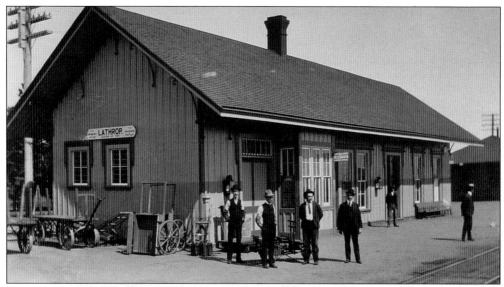

Six men stand in front of the Lathrop depot awaiting the next train. On December 31, 1869, the San Joaquin Valley Railroad began laying track south from Lathrop. Here they set up a base camp and began work. They had been given the right-of-way on local land by area farmers. This railroad line finally reached Los Angeles in 1876. (Courtesy of Roy Tinnin.)

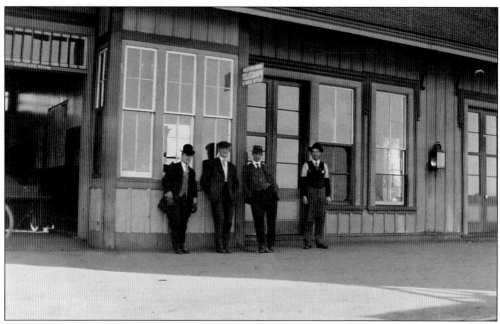

These four distinguished-looking fellows are standing in front of the depot building. The man on the right is most likely the station agent. The open doorway to the left is the baggage room, as indicated at the top of the door frame in small lettering. (Courtesy of Roy Tinnin.)

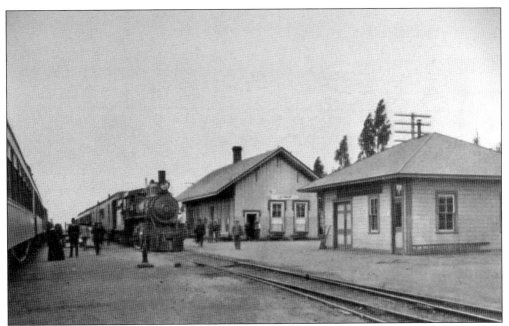

This photograph shows Lathrop depot from the north. Around 1880, Lathrop was a busy station. The roundhouse here was especially significant in maintaining engines because the closest roundhouse was over 150 miles away in Tulare, southeast of Lathrop. On April 25, 1891, the 23rd president, Benjamin Harrison, stopped at Lathrop during a tour of the United States and gave a public address to the county residents. (Courtesy of Roy Tinnin.)

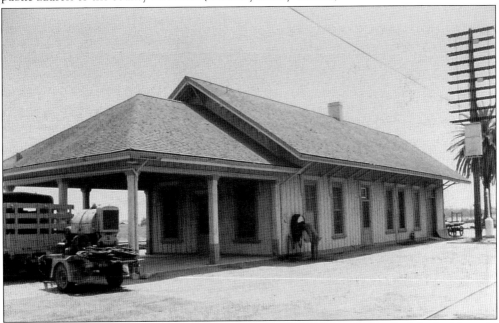

Here is Lathrop depot with the addition of a covered port to the north end of the building. At one time, there were benches under the cover for passengers to wait comfortably for the trains or people to wait for arriving passengers. In 1946, the Sacramento Daylight train started running between Lathrop and Sacramento. (Courtesy of Roy Tinnin.)

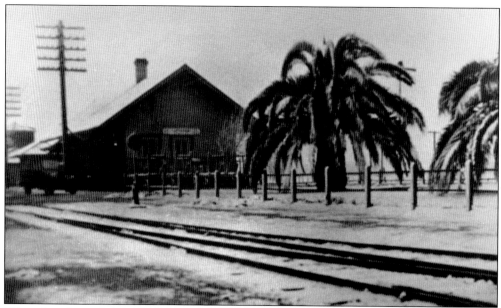

When this photograph was taken around 1950, there had been a rare snowfall in Lathrop. A light dusting of snow can be seen on the ground. In the early 1950s, almost all the passenger traffic for the San Joaquin Valley Railroad went on to Lathrop from Tracy before going south on the valley main line. (Courtesy of Roy Tinnin.)

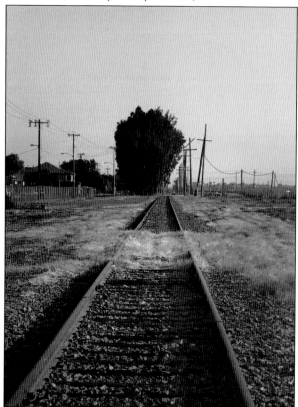

These railroad tracks were on the west side of the Lathrop depot buildings. They are now overgrown with grass, but the tracks symbolize a key piece of Lathrop's history and the importance of the railroad to the area even today. The imagination can conjure up images of the busy railway line with the train station on the right side of these tracks. (Author's collection.)

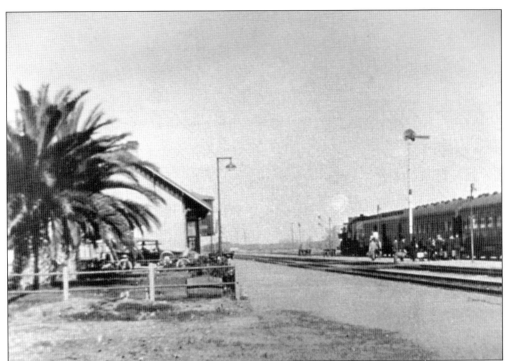

On the right in this scene of the depot, passengers are lined up to board a train. The water tank is just visible past the depot building between the light pole and the building. The two palm trees on the left are all that remain on the old depot site now. (Courtesy of Mac Freeman.)

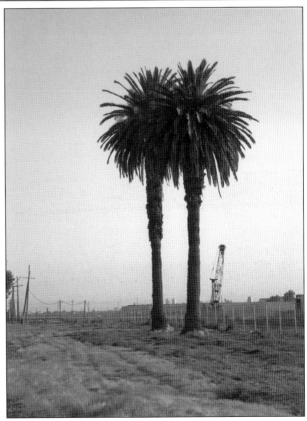

Lathrop depot was removed in the early 1970s, but these two palm trees have remained and thrived. Notice how tall they have grown throughout the years. At one time, there were also rose gardens by the palm trees. The Lathrop connection between the Sacramento Daylight and the San Joaquin Daylight trains was eliminated on August 2, 1970. Passengers on these trains were then transferred at Tracy. (Author's collection.)

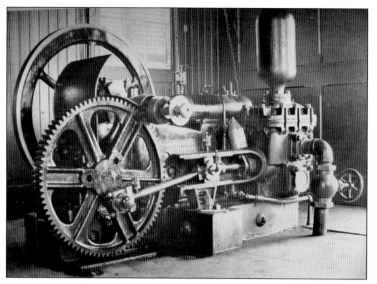

This motorized water pump was used to fill the locomotive's tanks. Located inside a pump house near the tracks, the pump drew water from the river or another nearby water source to refuel the trains. Steam trains especially used a large quantity of water. When the tank got too low, a float activated the pump to refill the tank with water. (Courtesy of Mac Freeman.)

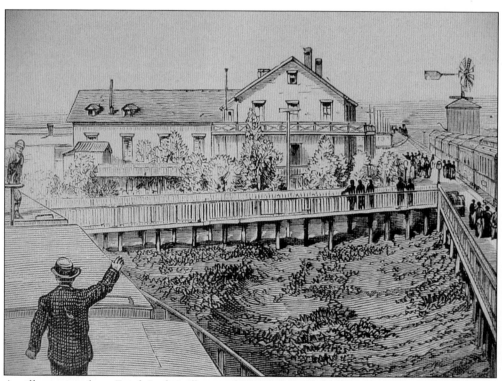

An illustration from *Frank Leslie's Illustrated Newspaper,* dated May 11, 1878, shows the hotel opened in May 1871. With the hotel situated in the wye of the railroad tracks, wooden walkways were built from the trains to keep people out of the mud in wet weather. H. A. Bloss was in charge of the hotel when it opened. The hotel burned down on February 26, 1886. (Courtesy of Mac Freeman.)

The railroad's hotel stood in the middle of the railroad wye in the location photographed here. The old wye between McKinley Avenue and Seventh Street is visible today as a raised dirt bed. A wye is where railroad tracks are laid in a Y shape for reversing the direction of the train. The old wye was substantially narrower than the tracks laid for the wye used today. (Author's collection.)

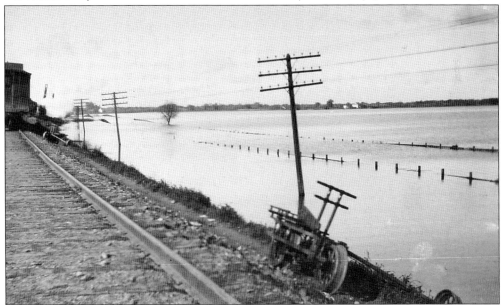

The railroad handcar seen here in the lower right corner was used for men to go out to inspect and maintain the rails. The type of handcar seen here is of the levered design, which uses a hand pump to propel it forward. This handcar style was developed in the latter part of the 1850s and into the 1860s. (Courtesy of Mac Freeman.)

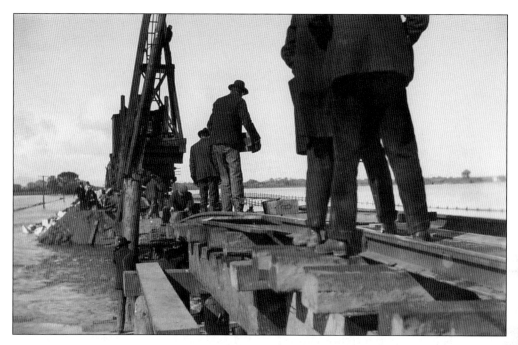

These men are repairing rails after a flood washed out the piling. It must have been cumbersome to do the work, as they did not remove their jackets to do the job. Some of the men stand along the rails passing supplies hand to hand. The river crossing shown is thought to be either the Mossdale railroad bridge crossing during the early 1900s, or it may be between Paradise Cut and the San Joaquin River. Flooding of Mossdale and Lathrop has been enough that in the winter of 1982, building in the area came to a standstill. The city is protected by levees along the San Joaquin River; but with wet enough weather, the potential for flooding is still there. (Courtesy of Mac Freeman.)

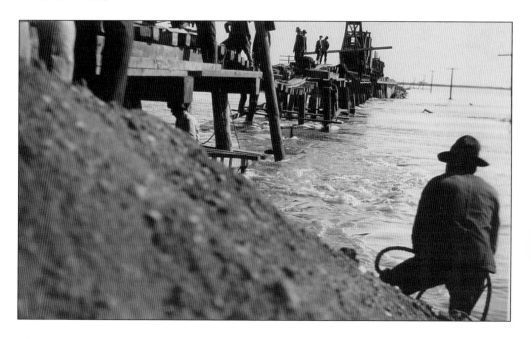

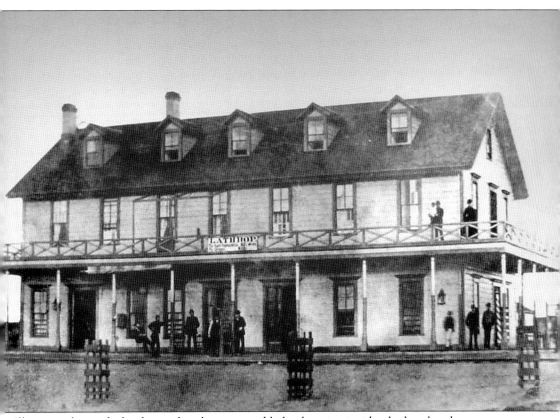

Illuminated at night by the outdoor lanterns and lights burning inside, the hotel and restaurant shown here must have been a site to behold as one approached it by rail. There are a number of people milling about outside the hotel. A man and child sit at the rail on the balcony with a woman by their side; others take in the view from the porch below. Perhaps these folks are visitors to the town or maybe employees of the hotel. This hotel was also built in the wye of the railroad tracks. Constructed in 1889, it was the third railroad hotel to occupy that spot and perhaps the most famous, as it was also the site of a murder. The sign on the front of the building identifies the town and gives the distance to San Francisco and Ogden. A devastating fire once again claimed this railroad hotel in 1892. (Courtesy of Mac Freeman.)

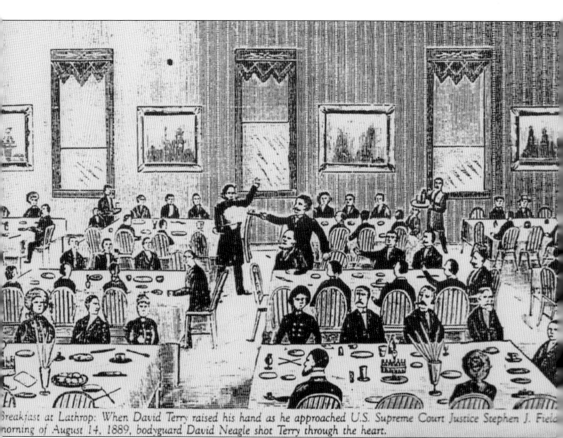

Breakfast at Lathrop: When David Terry raised his hand as he approached U.S. Supreme Court Justice Stephen J. Field morning of August 14, 1889, bodyguard David Neagle shot Terry through the heart.

Tragedy struck the dining room of the railroad hotel on August 14, 1889, when U.S. Marshal David Neagle shot and killed former California Supreme Court judge David Smith Terry with a bullet through the heart. At the time, Neagle was acting as bodyguard to Justice Stephen J. Field and reacted when Terry assaulted Field. Terry had much hatred for Field after he imprisoned Terry and his wife, Sarah Althea Hill, during a portion of a legal case regarding Sen. William Sharon shortly before this incident in Lathrop. Neagle was sent to federal court in San Francisco, where he was acquitted on murder charges. One year later, the U.S. Supreme Court defended his actions and set the precedent, giving authority to U.S. Marshals to employ force while doing their lawful duties. On October 26, 1996, a plaque was placed near the murder location for historical interest. (Courtesy of Mac Freeman.)

Two

HISTORIC DOWNTOWN

For some time, there were few roads in Lathrop; the main roads were Seventh, Sixth, and Fifth Streets and McKinley Avenue. In those early days, Seventh Street was the heart of downtown and a hub of activity where most business was conducted. The railroad tracks ran right along Seventh Street. In 1879, downtown consisted of about 24 buildings, including three hotels (the Central, the Lathrop House, and the Shannon House), seven saloons, two restaurants, two general merchandise stores, a bakery, two blacksmith shops, several freighting companies, and a school. The population at that time was 600 people. In 1882, the main teaming stagecoach and wagon road from San Jose to Stockton passed Lathrop a half mile to the west. Today Seventh Street is home to a number of businesses, including the police department, the post office, the library, and restaurants. The senior center and community center are located on Fifth Street. Although Lathrop has grown significantly out from the old downtown area, Seventh Street and its surrounding roads remain the root of Lathrop.

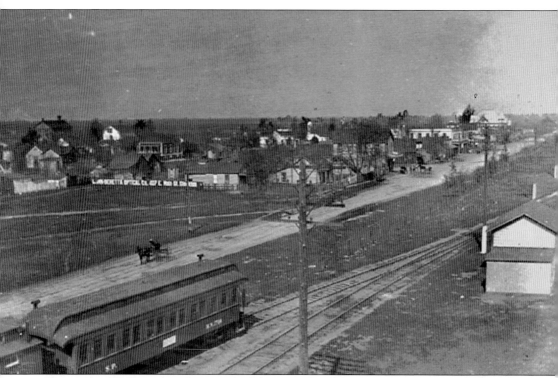

This view of Lathrop was photographed from a railroad water tank. In the upper left corner is the schoolhouse with the Brethren Church to its right. The buildings of Seventh Street stand tall along that stretch of dirt road. At the far end of Seventh Street, the large white roof of the Sanguinetti Store can be seen. A horse and wagon heading out of downtown can be seen just above the passenger railcar. A postcard found with this photograph identifies the people in the wagon as a Mrs. Watson and Jack. The train is also headed away from the depot toward the edge of town. Railroad buildings are visible in the lower right, with storage for tools and other railroad equipment. An early billboard is on the fence in the middle of the picture. The advertisement is for an optical business on East Main Street in Stockton. (Courtesy of Mac Freeman.)

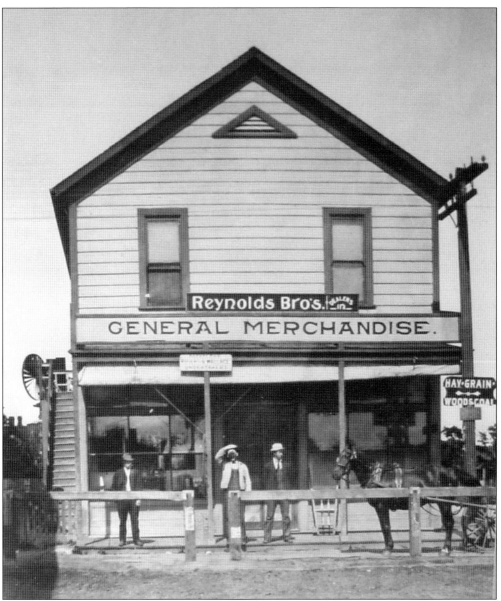

The general merchandise store seen here changed hands several times over the course of its history. Early Lathrop pioneers Sydney W. Reynolds and his brother Edwin Reynolds bought this store from B. F. Eastman and a Mr. McKee around 1900. After four years of running the store together, Sydney bought Edwin's share of the store. Sydney continued to run the store for one more year before selling it to John H. Southwell in 1906. Three gentlemen are standing behind the hitching posts in front of the clapboard building, with a horse and cart at the ready for more customers. Reynolds Brothers carried a number of farm staple items, including hay, grain, wood, and coal. Visible above the man shading his eyes from the sun is a sign for Rogers and Wallace Undertakers, which must have shared the building with Reynolds Brothers. (Courtesy of Mac Freeman.)

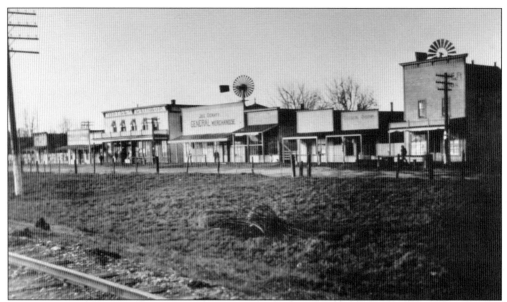

Pictured here in 1903 are businesses along Seventh Street between J and K Streets. They included Chee Ng Laundry, Chas Eaton's saloon, Mrs. Southwell's restaurant, Hotel Lathrop, Joseph Geraty General Merchandise, Cardwell's Butcher, C. D. Snow's office, J. D. Cowden's barbershop, and a saloon run by Peter Alex. The road was originally called Front Street, and then the name was changed to Main Street before becoming Seventh Street, as it is known today. (Courtesy of Mac Freeman.)

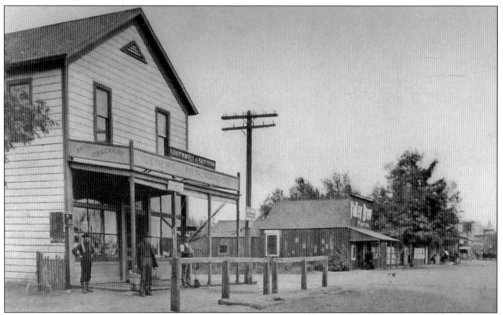

This building is Southwell and Sutton General Merchandise, located on the corner of K and Seventh Streets in the early 1900s. The man on the far right is John Southwell, who, after leaving his post as head agent of the Wells Fargo office, partnered with his father-in-law D. T. Sutton, running the mercantile in 1906. Most buildings in this photograph were destroyed by fire in May 1927. (Courtesy of Mac Freeman.)

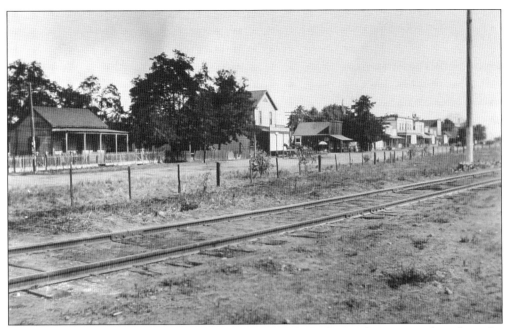

This photograph shows the length of Seventh Street from the north as it stretches along the railroad tracks. In 1890, Lathrop boasted three hotels, two restaurants, and two general stores. One general store was kept by Geraty and the other by Dario Sanguinetti. Scarlett and Howland were the town's main grocers. (Courtesy of Mac Freeman.)

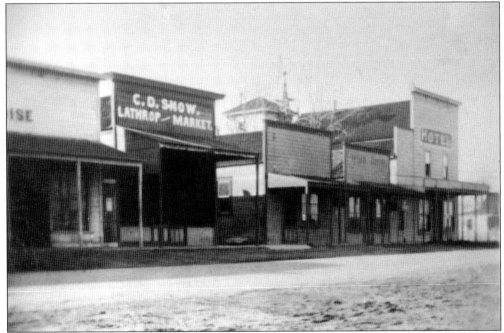

Shown in this street scene are Geraty's General Merchandise (left) and the C. D. Snow Lathrop Market. In a seemingly empty building, a barbershop and a smaller hotel still lined Seventh Street between J and K Streets in the early 1900s. Snow was also a butcher in town. (Courtesy of Mac Freeman.)

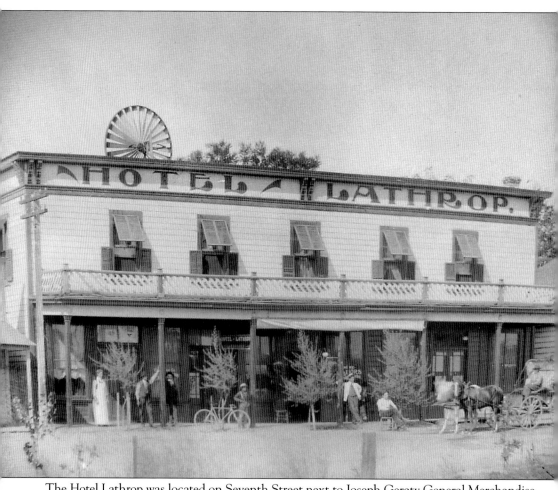

The Hotel Lathrop was located on Seventh Street next to Joseph Geraty General Merchandise. The clapboard hotel was built sometime after 1870 and was owned by R. T. Shannon and L. M. Baird. It is a relaxed setting here, as people stand or sit about and enjoy the rural street scene before them. Their attention at the moment is focused on the man who is arriving in his horse-drawn buggy. The entrance to the hotel was the door below where the small Hotel Lathrop sign is hanging under the eave. All of the windows on the upper floor are wide open to allow in the valley breeze. The blades of a large windmill are just visible over the roof of the hotel. The Hotel Lathrop provided a warm bed, hot meal, and comfort for many travelers through town, who were weary after long days and nights on the train. (Courtesy of Mac Freeman.)

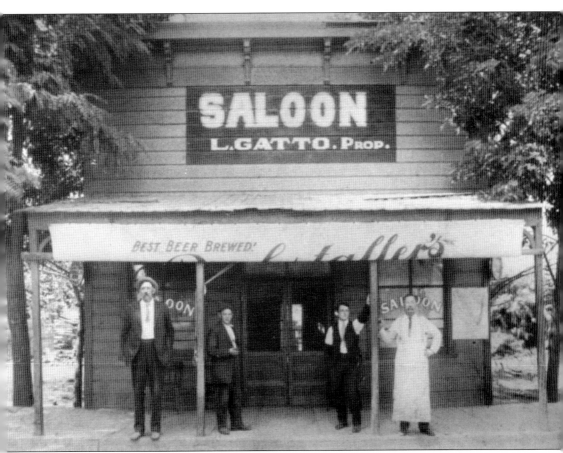

Luigi Gatto's saloon was on the south side of the Lathrop Hotel and surrounded by trees. A banner hangs, which when unfurled, advertised Ruhstaller's lager, the "best beer brewed." Shown here around 1910, several men pass the time of day on the wooden board sidewalk in front of the saloon. Shortly before this in 1909, Gatto had trouble getting his liquor license. According to the *San Francisco Call* newspaper from October 6, 1909, despite Gatto's petition bearing 96 signatures, his application for the license was rejected by the board of supervisors. At the time, Lathrop was somewhat of a dry town, so there was opposition to the manufacturing or selling of alcoholic beverages. This changed in November 1910, when Lathrop was the only dry town in San Joaquin County to vote to become wet. The allowance of alcohol did not win by a very big margin, with 56 votes for saloons and 51 against saloons. (Courtesy of Mac Freeman.)

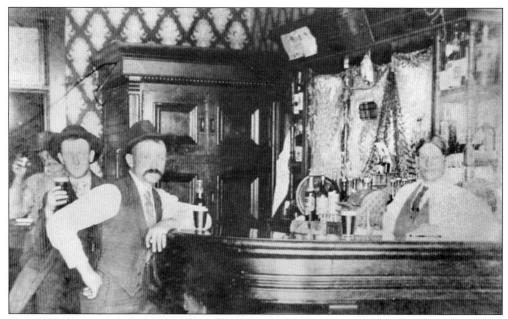

Several dashing gentleman enjoy their drinks at the bar inside Luigi Gatto's saloon. The man behind the bar is a Mr. Abersold. The bar appears to be situated in the corner of the saloon; just to its left is the bar's back door. The men are dressed in the fashion of the day: hat, tie, vest, and jacket. (Courtesy of Mac Freeman.)

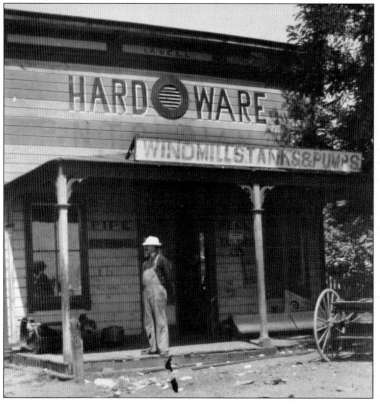

L. A. Bell's hardware store sat on the west side of Sixth Street just south of L Street, where a home occupies the site now. This early hardware store carried everything from buckets to windmills, water well supplies, and more. Papers litter the street in front of the store, as a man gets some air out on the wooden porch. (Courtesy of Mac Freeman.)

These gentlemen are standing on the porch of Bell's hardware store. The man on the left with the washing machine is Hiram Miller, who bought the store from Bell in the early 1900s. An interesting detail to take notice of is the advertisement for the Woodman Picnic posted on the wall to the left of the door. (Courtesy of Mac Freeman.)

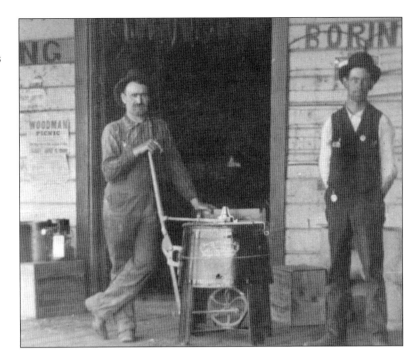

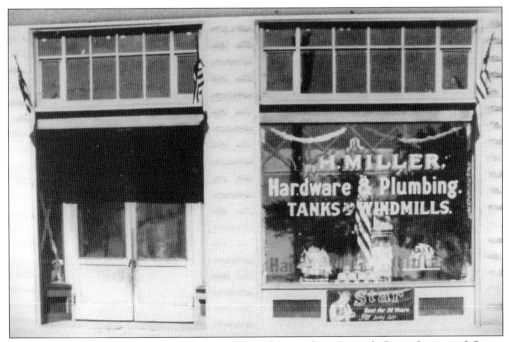

Miller's hardware store was completed in 1917 and located on Seventh Street between J Street and K Street. It was built where the Hotel Lathrop had once stood. Proudly displaying a row of American flags across the storefront, Miller's hardware showcased wares in the large windows in the store's facade. Star tobacco is advertised in a banner underneath one of the windows. (Courtesy of Mac Freeman.)

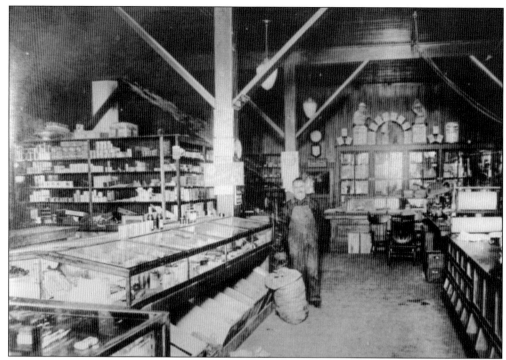

Hiram Miller proudly stands inside his well-laid-out hardware store. Upon entering the double doors, one sees the variety and vast array of goods available for purchase. Everything is organized in bins and glass cases. Boxes and cans of goods are neatly displayed on shelves. (Courtesy of Mac Freeman.)

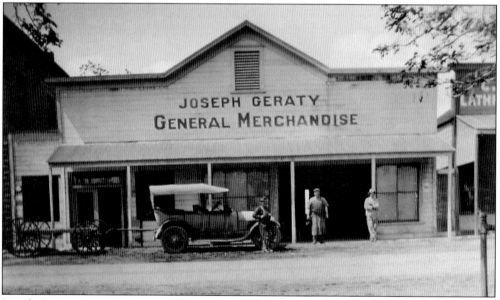

Joseph Geraty General Merchandise store is seen here with Lathrop market (far right), owned by C. D. Snow. The man standing against the car is Miller. The other two gentlemen are unidentified. At some time, Miller bought the store from Geraty and turned it into an automobile repair garage. (Courtesy of Mac Freeman.)

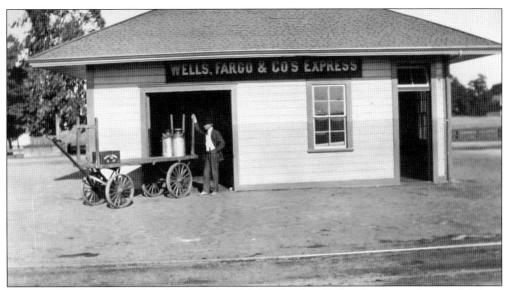

The man at the Wells Fargo Express office is John Southwell. Southwell was born in Utah in 1882. His father worked for Southern Pacific Railroad, and his mother ran the Shannon House in Lathrop across from the train depot. In 1904, he married Estella Sutton and worked as an agent with Wells Fargo until 1906. In 1918, Southwell and his family moved to Stockton. (Courtesy of Roy Tinnin.)

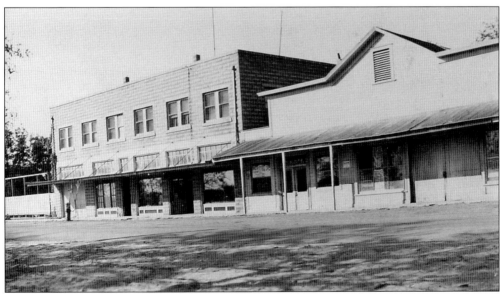

In 1920, this stretch of Seventh Street appears to be in transition. The general merchandise sign is missing from the front of Geraty's building. The brick building to its left is the W. H. Miller Hardware Store, occupying the property where the old Lathrop Hotel once stood. (Courtesy of Mac Freeman.)

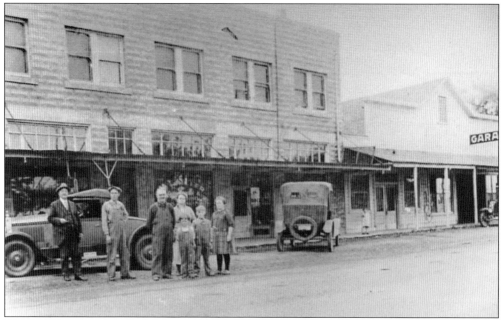

The Miller family stands in front of their hardware store. The gentleman in overalls is Hiram Miller. The man on the far left is Mr. Shannon, who sold real estate out of a room in the building. By this time, Miller had already converted Joseph Geraty's old store into an automobile garage, which he then owned. (Courtesy of Mac Freeman.)

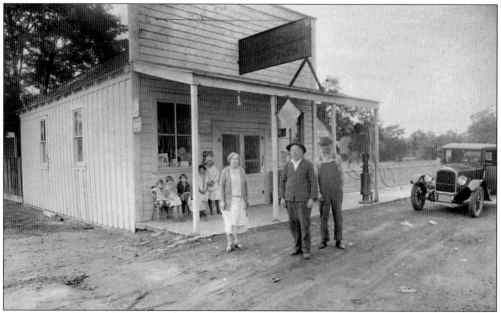

Whitlock's store was located on the corner of K and Seventh Streets. This building replaced Reynolds General Merchandise after the Reynolds store burned down in 1927. The unidentified folks posing outside the shop look like they are out taking care of their daily business. A sun hat is visible on display in the window. Children occupy the porch of the store, waiting with their doll buggy. (Courtesy of Mac Freeman.)

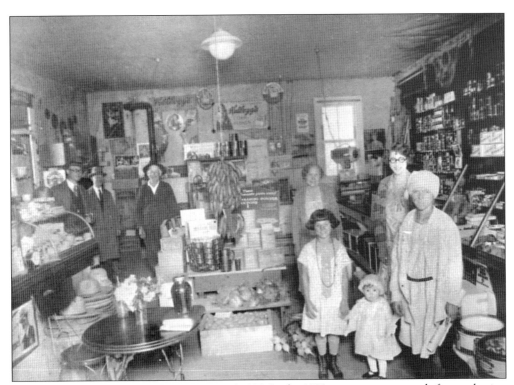

This is the interior of Whitlock's store around 1930. In the 1930s, stores were not only for purchasing goods but also were gathering places to socialize with neighbors and share news. Whitlock's store was well stocked with food, dry goods, and a candy counter to the right. The little girls are dressed up for their shopping, wearing Mary Janes, button-up boots, hats, and necklaces. (Courtesy of Mac Freeman.)

Ralph O. Yardley did this illustration of the Shannon House. The Shannon House stood next to Geraty's store and was one of several hotels to occupy that space over the years. The Shannon House burned on September 20, 1886. Beginning in the kitchen, the fire burned quickly and destroyed the hotel. Geraty's merchandise was mostly saved, but the nearby Chee Ng laundry was lost. The fire destroyed most of the downtown. (Courtesy of Mac Freeman.)

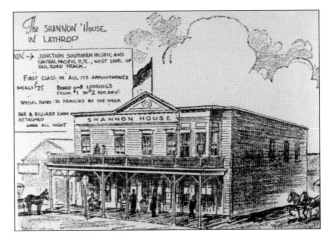

Louis Sanguinetti is just one of many Sanguinettis in Lathrop and surrounding areas. He and his cousin Emile were local sheep raisers around 1918. A number of Sanguinettis were involved in various agricultural endeavors, including farming, sheep raising, and vineyards. (Courtesy of San Joaquin Historical Society and Museum.)

This lovely view of Front Street, now Seventh Street, shows the Sanguinetti store and a horse and buggy on the right. The grand building, which housed the store and Sanguinetti residence, was an anchor to the north end of downtown Lathrop. One can just see down the length of the street to the Hotel Lathrop near the opposite end. (Courtesy of Mac Freeman.)

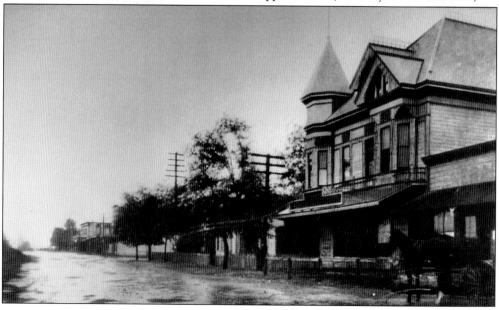

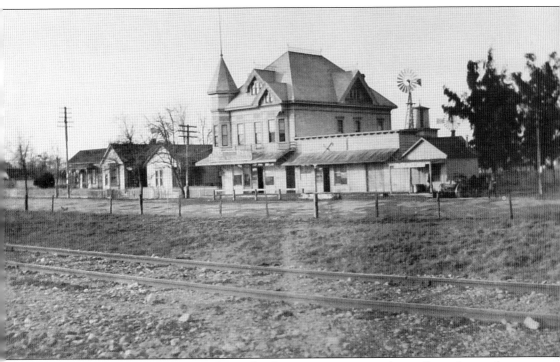

A landmark building in historic Lathrop, the Sanguinetti store stood proudly at the northern end of Seventh Street across from the railroad tracks. Dario Sanguinetti and his family made their residence in the rooms on the upper floor, with their general merchandise store down below. Little can be found about Dario, but the Sanguinetti name is one that was and remains today prevalent in various parts of San Joaquin County. Seen here, the building is a gorgeous example of Victorian architecture, with three gables visible and a cupola complete with lightning rod. A horse and buggy waits at the end of the store building. Also visible in the photograph are the homes to the south of the store and several windmills, as well as the hitching posts in front of the building. The stately wood structure burned down in 1927. (Courtesy of Mac Freeman.)

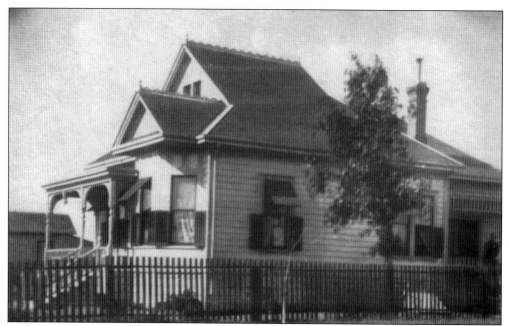

This working-class cottage is a lovely example of the architecture of the Victorian era. Note the intricate decoration and detail of the exterior. A gable graces the facade with fancy woodwork along its roofline, as well as the main one above it. The porch posts are adorned with angled brackets, and most windows have shutters. (Courtesy of Arnita Montiel.)

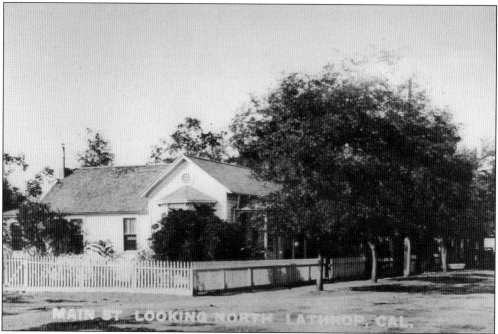

This quaint home is on the northwest corner of J Street and Seventh Street. This house is hard to spot today, as the trees have filled in even more and there are changes to the house's facade. Despite the passage of time and these differences, one can still see the home's charm. (Courtesy of Mac Freeman.)

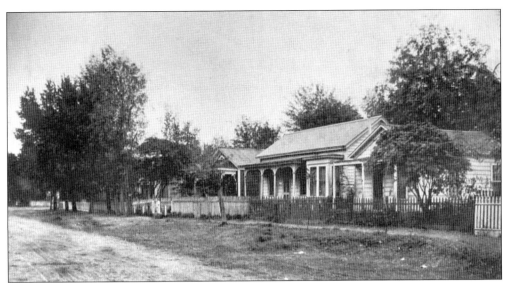

These homes are on Sixth Street between K and L Streets. The white house in the foreground once belonged to a doctor. To accommodate patients, upon entering the house, one could go left or right. The house was the doctor's home and his office, so it was set up with the residence to one side and patient waiting area and exam rooms to the other. (Courtesy of Mac Freeman.)

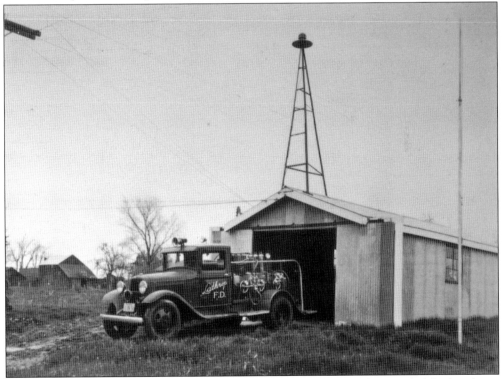

Pictured here is the Lathrop firehouse at Sixth Street and J Street. At the sound of the fire alarm, the firemen ran and jumped on the platform at the back of the truck, grabbing onto the handrails. Lathrop's volunteer fire department began in 1936. Now named Lathrop-Manteca Fire Protection District, it serves Lathrop, its rural areas, and rural Manteca. (Courtesy of Mac Freeman.)

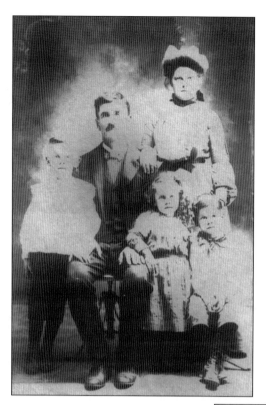

William Elliott and his wife, Lennie, brought their family to California from Wisconsin around 1909. The children from left to right are Nile Elliott, Ada Elliott-Hubbard, and Artie Elliott. Later in his life, Nile was the first school bus driver for Lathrop. He retired in 1962. Artie worked for Southern Pacific Railroad and is the father of Arnita Montiel, who still resides in Lathrop. (Courtesy of Arnita Montiel.)

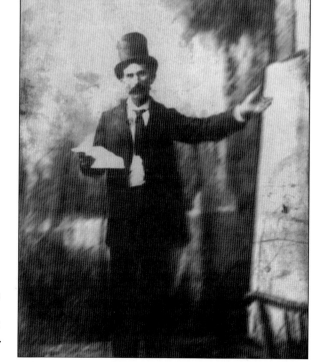

Raynaldo Gallego, shown here in the early 1900s, was a constable in Lathrop in the early days. Posed here in his top hat, coat, and tie, he looks to be ready to give a speech. Gallego is the maternal grandfather of lifelong Lathrop resident Montiel. (Courtesy of Arnita Montiel.)

Taken on October 24, 1953, at the corner of Sixth and L Streets, this photograph shows the peacefulness of Lathrop's residential streets. Nearby J Street was similar to this but wider than normal to allow for the six-horse supply wagons from downtown. Fifth, Sixth, and Seventh Streets could not accommodate the wagons, so in the 1800s and early 1900s, they turned around on J Street. (Courtesy of Mac Freeman.)

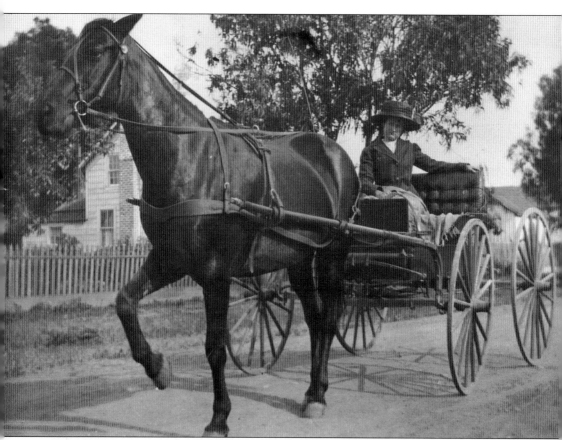

Sarah Sperry is out for a ride in her horse and buggy on Sixth Street. It must have been a chilly day, as she is decked out in a hat and jacket, and has a blanket over her lap. Her horse is mid-step, and around him there is a charming clapboard farmhouse. The picket fence and dirt road add to the serenity of this picture. Although the wagon wheels are of a good size, in rainy weather, the going was rough over wet and muddy roads. The Sperrys were a large, prominent family in the area. They owned a flour mill in Stockton and were involved in farming pursuits around the vicinity as well. The woman photographed here was likely the wife (maiden name McClary) of James Cargil Sperry. He was a local farmer, and they resided in the Lathrop area in the late 1890s and early 1900s. (Courtesy of Mac Freeman.)

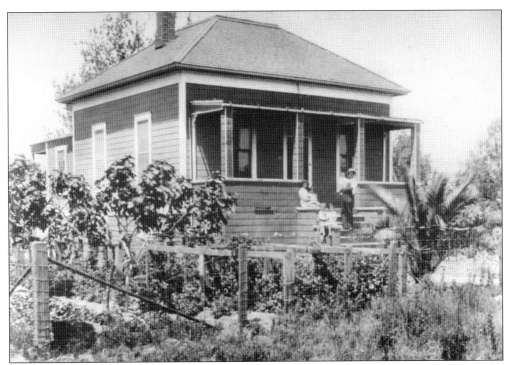

Luigi Gatto, his wife, Jessie, and four of their ten children pose in front of their home on the northeast corner of Sixth Street and K Street. Luigi is standing on the step holding Eva. Jessie is seated against the porch wall with son Fred; the two children seated in front are Johnny (left) and Clara. Gatto was born in 1862 in Italy. (Courtesy of Mac Freeman.)

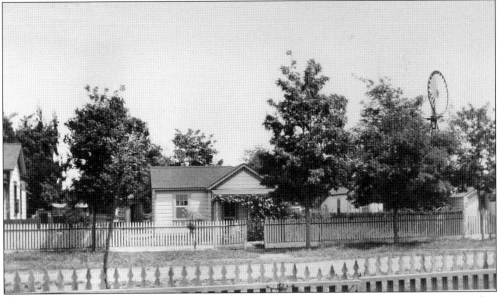

This inviting home sits on the west side of Sixth Street between K and L Streets. A flower arbor graces the front porch on which a young woman is sitting. The open gate in the picket fence is a warm invitation into the welcoming yard. A windmill is seen at the right side of the photograph, standing as tall as the tree tops. (Courtesy of Mac Freeman.)

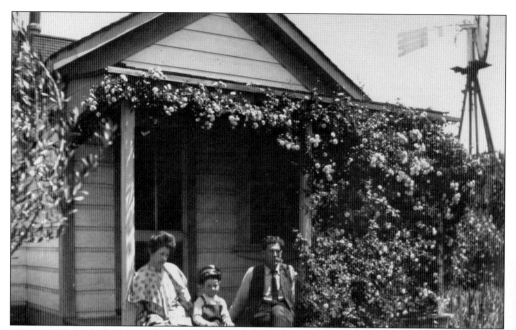

These unidentified people may be the residents of this home on Sixth Street between K and L Streets, or they may be visiting here. They find rest, as they sit in the sun and enjoy the porch with its beautiful climbing rose. (Courtesy of Mac Freeman.)

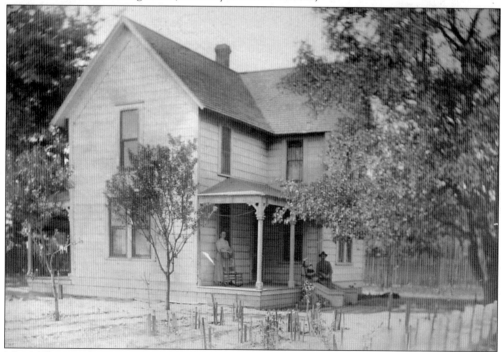

Mrs. Miller, standing on the porch, and Mr. Miller, with a child on the steps, lived in this farmhouse until they built their store on Seventh Street around 1919. The home was known as the Cargile house after the Millers moved. The Cargile family lived in it for many years. The house, which still stands today, is on Sixth Street between H and I Streets. (Courtesy of Mac Freeman.)

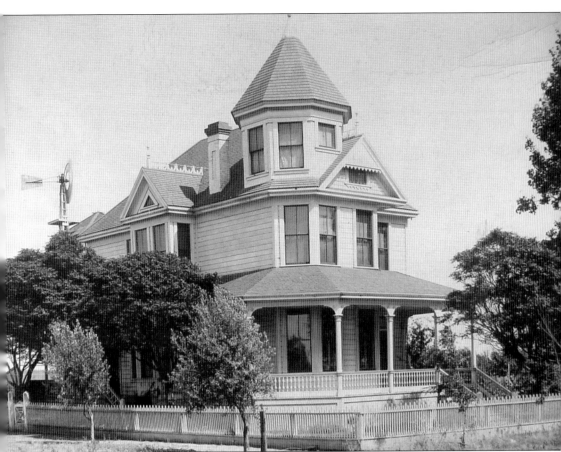

This beautiful Victorian home stands on the corner of Thomson Road and Fifth Street. Boasting 10 rooms, the clapboard house was built in 1893 by Eldon H. Gordon, a worker for the Southern Pacific Railroad. Gordon sold the house in 1896 local saloon keeper Peter Alex. Other residents of the house include Rev. Martin Southern and his wife, who made it their home for 36 years. Part of the charm of the house is its white picket fence with an intricate gate to the far left. A number of trees grace the front and side yards to offer shade and privacy. There was also great attention paid to detail in building the structure, as shown by the decorative woodwork on the gables. Today the house looks much the same; the biggest change that is visible from the outside is the removal of the cupola. (Courtesy of Mac Freeman.)

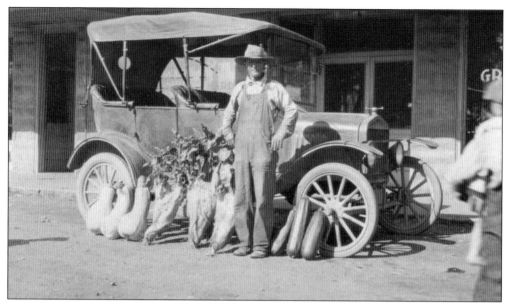

Alec Thomsen, shown here in 1925, donated land for Thomsen Road and Louise Avenue in Lathrop. Thomsen Road was eventually named after Thomsen but was known as M Street for a while. He proudly stands with an impressive array of squash, zucchini, and other vegetables. (Courtesy of Mac Freeman.)

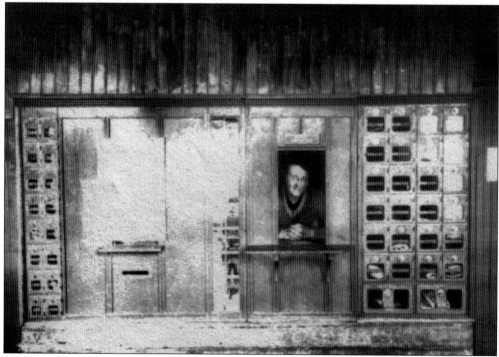

Flo Kliest looks through the window of an early Lathrop post office. There are relatively few mailboxes, as Lathrop was not a large town then and for the most part only the folks who lived close to the post office had boxes. Those who lived farther out most likely had their mail delivered by the mail carrier. (Courtesy of Arnita Montiel.)

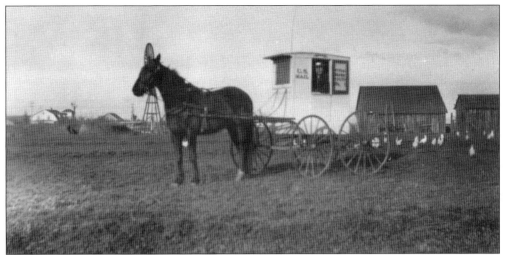

Bill Ryhiner sits in his horse-drawn mail wagon sometime prior to 1913. Ryhiner served Lathrop for many years as a mail carrier, delivering mail to those in town and those in the rural areas. There are chickens roaming in the field behind the wagon. The Wolfe family residence can be seen in the distance on the far left. (Courtesy of Mac Freeman.)

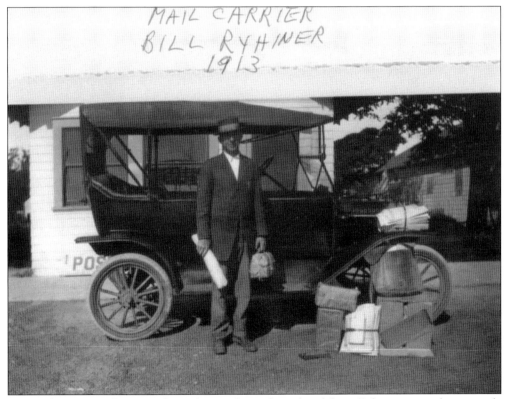

The Lathrop post office was a busy place with much mail to deliver. Ryhiner is seen here outside the post office with his deliveries for the day. It is quite a pile of mail bundles he has to deliver. By this time, he was covering his route with his automobile instead of his horse and buggy. (Courtesy of Mac Freeman.)

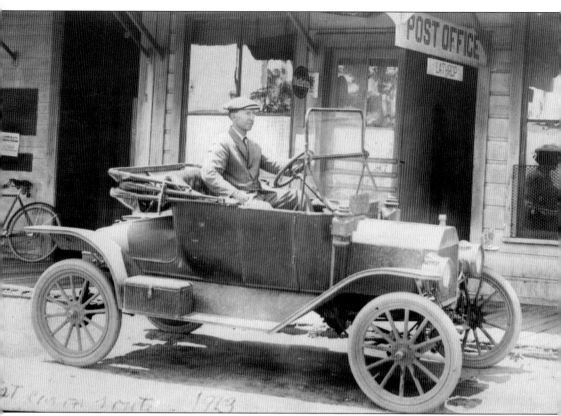

Mail carrier Bill Ryhiner sits outside the post office in his first car. He bought this Ford Model T Open Runabout on May 21, 1913. Born June 26, 1882, in Vacaville, Ryhiner was a mail carrier for several decades in the rural areas of Lathrop, as well as nearby Ripon and Manteca. Neither of those towns had a post office of their own, so the one in Lathrop was responsible for their mail in addition to its own for a time. Ryhiner delivered it all. In one day, he traveled around Lathrop and also out to Manteca and Ripon. On warm but not hot days, it must have been a pleasant drive on the country roads. On the wall above the bicycle is a notice for a grand ball that was taking place around that time. (Courtesy of Mac Freeman.)

The couple seen here are Ryhiner and his wife, Ethel Russell Ryhiner. The photograph was taken on November 2, 1974, at the dedication of the Lathrop Community Center. Ryhiner had been on the advisory board for this project and was around 92 years old at the time. Ryhiner was also instrumental in the introduction of street lighting in the city. (Courtesy of Mac Freeman.)

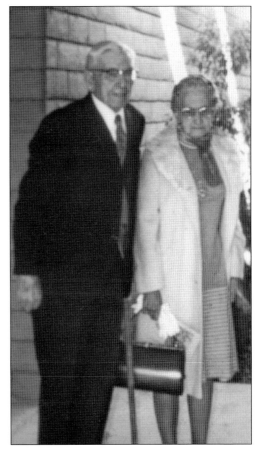

Storm clouds fill the sky over the Wolfe house, once home to the Wolfe family. Spreading out behind the house are floodwaters. The Wolfe house is on Thomsen Road, and although it stands alone in this photograph, it is today surrounded on all sides by houses, parks, and churches. (Courtesy of Mac Freeman.)

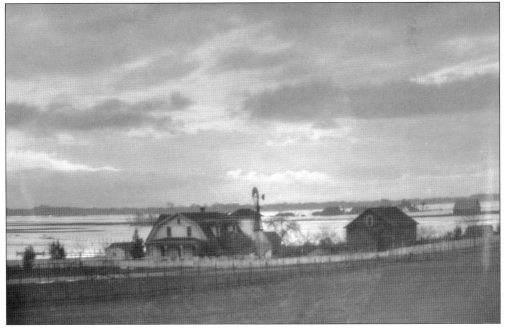

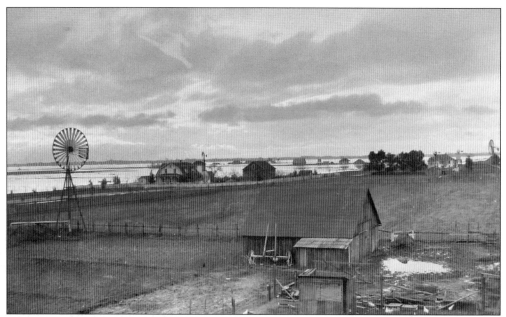

Lathrop has seen a number of floods over the years. Stockton to the north lies lower than Lathrop, so the waters flow north. When it flooded, the water rose to Highway 50 but not over it. The Mossdale area was especially prone to flooding. The levees protected the area from rising waters but have been breached on more than one occasion in Lathrop's history. (Courtesy of Mac Freeman.)

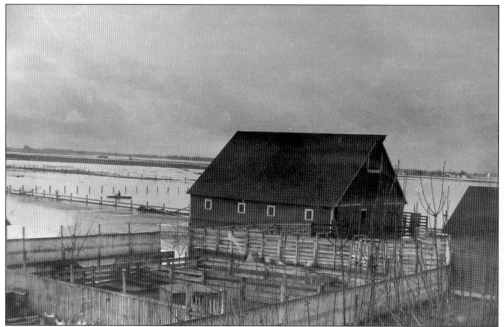

Here is a barn and some animal pens standing in floodwaters west of Lathrop. Flooding has occurred despite the levees that have been along the San Joaquin River for many years. Around 1868, Reclamation District 17 was authorized to work on the east levee of the river. Costing $9 per acre, 16 1/4 miles of levee work were funded by landowners. (Courtesy of Mac Freeman.)

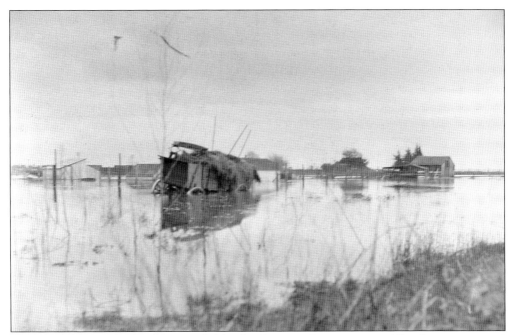

Barns and a hay wagon are surrounded by floodwaters. One instance of flooding was around January 25, 1890, as a newspaper reported that levees were safe, but people were still uncertain because the river was expected to rise. Due to slides at Altamont and blocked tracks there, no trains were arriving from San Francisco that day. (Courtesy of Mac Freeman.)

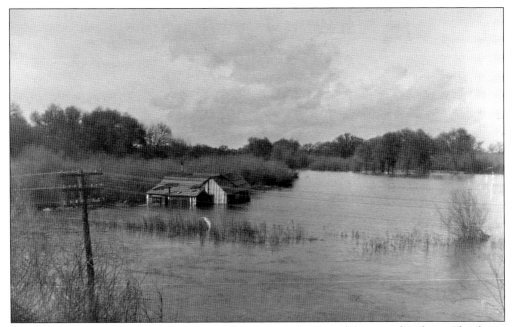

Standing in at least a few feet of water is a house near the Mossdale area of Lathrop. Floods are not uncommon in the area. The San Joaquin River is California's second-longest river. With this 330-mile river next to it, there are records of the Lathrop area flooding from the late 1800s to the present day. (Courtesy of Roy Tinnin.)

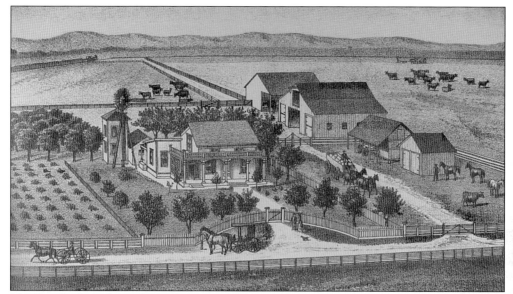

The Howland ranch was located on Howland Road, one mile south of downtown. The Simplot fertilizer plant now stands on the land. H. S. Howland came to Lathrop in 1869. Lerosco Howland, his son, bought 185 acres of land in 1883. After selling 160 of that in 1887 to be divided into town lots, he fixed up his land with the beautiful ranch illustrated here. (Courtesy of Roy Tinnin.)

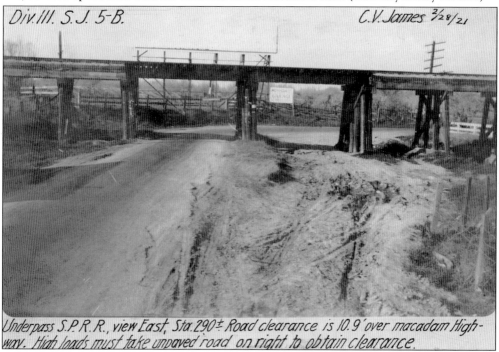

This view is looking east at the Southern Pacific Railroad underpass in Mossdale. Charles Abersold and Salvador Mauro shared ownership of the Mossdale Garage around 1918. A sign for the garage is visible below the underpass. The road is paved to the left, but due to the clearance of almost 11 feet, vehicles with higher loads still took the dirt road to the right. (Courtesy of the California Department of Transportation.)

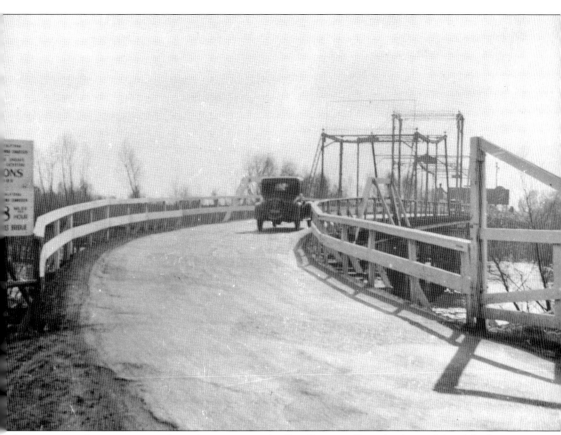

Imagine traveling in a car such as this one over the San Joaquin River bridge in Mossdale. It is such a step back in time, as the picture shows the automobile bridge, part of Highway 26, and the old Lincoln Highway as it looked in 1925. One can just make out the speed limit posted on the sign of 8 miles an hour. In the distance can be seen a couple of billboards, as the car traveling on the bridge heads east and the water rushes by in the San Joaquin River below. The framework above the bridge shows the beginning stages of its remodeling, which was completed in 1926. The 1926 bridge structure is what stands in use today. It is no longer part of any highway but is part Manthey Road and runs parallel to Highway 205 from Lathrop into Mossdale. (Copyright © 1925 California Department of Transportation.)

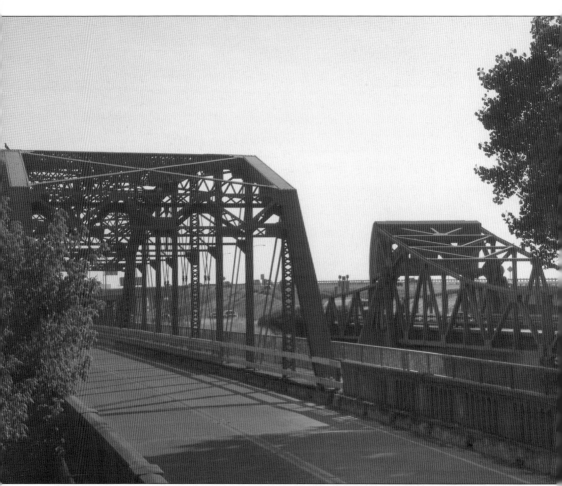

These automobile bridges are pictured as they stand today, situated between the railroad trestle to the north and Interstate 5 to the south. Together they are an impressive sight. The bridge on the left was built in 1926 and was part of the original Lincoln Highway. The famous Lincoln Highway locally ran south from Stockton through Lathrop on Harlan Road. The entire length of it stretched from New York to San Francisco. The old white boards from the original 1925 bridge can still be seen, although now they are reinforced with guardrails and concrete. The bridge on the right is reminiscent of the historic Highway 50 and was built around 1950. On the left between the railroad bridge and the 1926 bridge is a pedestrian bridge, allowing one to walk from the entrance of Mossdale Regional Park to the other side of the San Joaquin River. Both bridges are painted a bright, grassy green, making them stand out as one drives past on Highway 205. (Author's collection.)

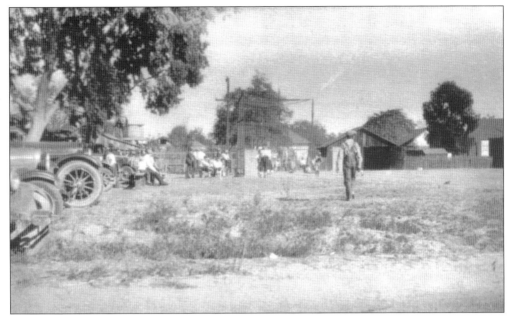

A good time was had by all playing baseball on this field on Fifth Street between K and J Streets. During the 1920s, baseball was a popular pastime on Sundays. There is nothing fancy here; just a backstop on a field of dirt was all they needed for an afternoon of good, old-fashioned fun. (Courtesy of Mac Freeman.)

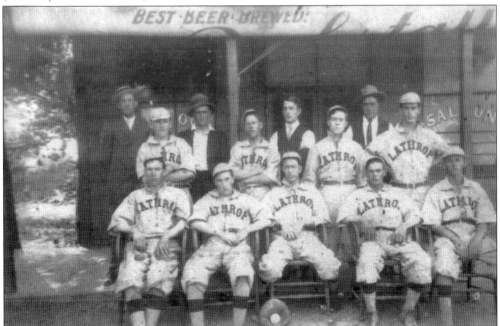

Members of Lathrop's baseball team, seen here in the 1920s or 1930s, are looking ready to play ball and to win. Suited up in uniform, they are posed in front of Luigi Gatto's saloon. The fellows standing behind the team are dressed in their Sunday best for an afternoon at the ball field. They all show an air of confidence as they look forward to their next game. (Courtesy of Arnita Montiel.)

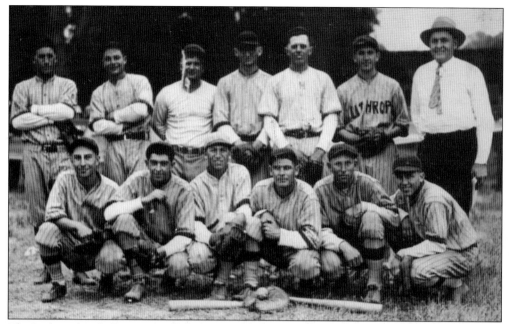

The Lathrop baseball team stands with their coach in 1923. At this time, baseball was rising to its status as America's favorite pastime. With new urban ballparks being built and players such as Babe Ruth, Roger Hornsby, and Joe DiMaggio to watch, the 1920s and 1930s saw baseball become a big entertainment, and radio broadcasts of ball games were hugely popular. (Courtesy of Mac Freeman.)

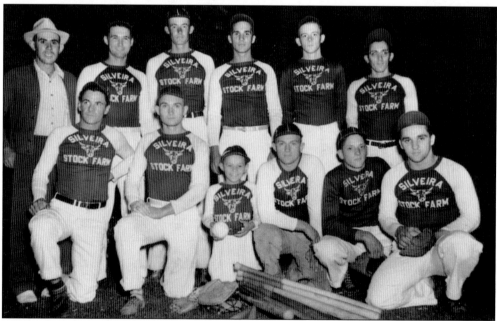

The Lathrop baseball team, sponsored by Silveira Stock Farm, is pictured here with bats and gloves. From left to right are (first row) Francis Zusto, Perry Tipton, unidentified, unidentified, Al Souza, Frank Teicheira; (second row) Al Silveira, ? Bronzen, Charlie Percival, Louie Brazen, Willard Reiger, and Sal Miniaci. (Courtesy of Mac Freeman.)

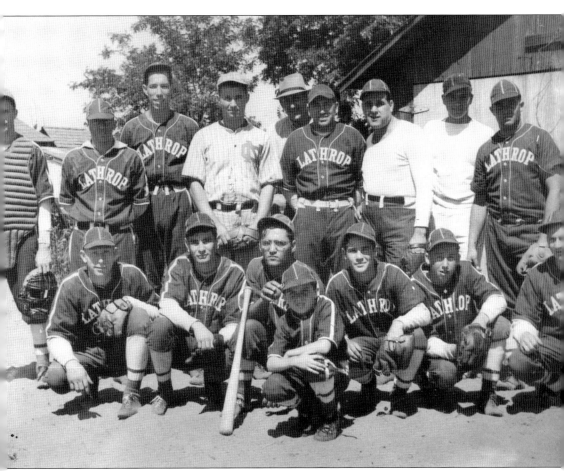

As they hope for a good crowd to cheer them on from along the baselines, members of the 1939 Lathrop baseball team pose next to the wooden building on the edge of the town ball field with mitts set to go. They are wearing their game faces and are ready for action on the diamond. Kliest is suited up in his catcher gear, set to take his position behind home plate. From left to right are (first row) Lynn Percival, Johnny Williams, Joe ?, Duane Wigley, Leland Elliott, Arthur Buck, Cyla Wigley; (second row) Earl Kliest, Sal Miniaci, Dick Crowl, ? Bronson, Mike Binacosa, Al Gallego, Joe Binacosa, unidentified, and ? Brockland. (Photograph by Milton McMurray; courtesy of Mac Freeman.)

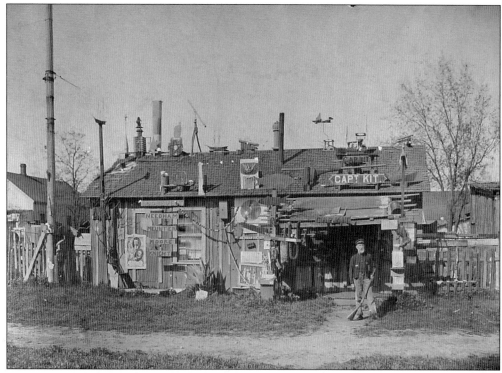

Captain Kit was Lathrop's colorful character from the 1950s and 1960s. He lived in this unique place, which was located on the west side of the alley between K and L Streets. He stands in front of his residence holding his rifle. His house is adorned with an eclectic collection of signs and objects. (Courtesy of Mac Freeman.)

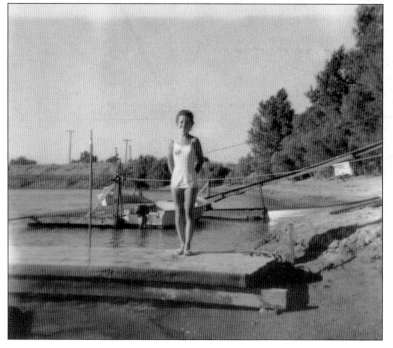

This young girl stands on a dock as she poses for a photograph along the banks of the San Joaquin River. Dressed in her swimsuit, she is ready for a day of fun, sun, and swimming in the cool waters. There are a couple small boats that can be seen docked behind her. (Courtesy of Diane Hirata.)

Three

EDUCATION AND RELIGION

Lathrop has a long history of providing education for the children of the community, beginning with the public school house built in 1855. Now part of the Manteca Unified School District, Lathrop boasts three elementary schools, including Joseph Widmer Jr., Lathrop School and Lathrop Annex (kindergarten through second grade), and Mossdale Elementary School. Lathrop's brand new high school officially opened for the 2008–2009 school year. There are sure to be more expansions and changes in years to come, as Lathrop continues to grow and thrive. Religion has always had a place as well. In the early days, Lathrop's religious communities consisted of the Brethren Church and the Catholic Church. Today many churches representing several denominations make their homes in Lathrop.

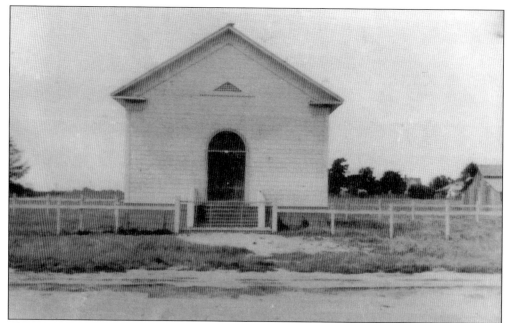

The Brethren Church building pictured here is on the corner of J and Fifth Streets. It was built in 1921. When the church was founded in the fall 1862, the Brethren Church in Lathrop was the first such in San Joaquin County. At this time, the members held a meeting in a grove at the east side of the San Joaquin River near the railroad crossing. (Courtesy of Arnita Montiel.)

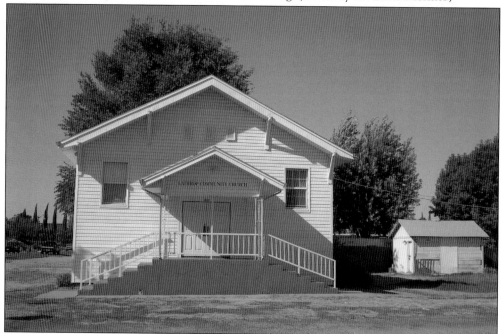

The Brethren Church building now houses Lathrop Community Church. In the 1960s or 1970s, the front stairs were entirely rebuilt. Instead of going straight down from the door, there is now a landing with several steps down each side. The church also has a small shed building towards the back of the property. (Author's collection.)

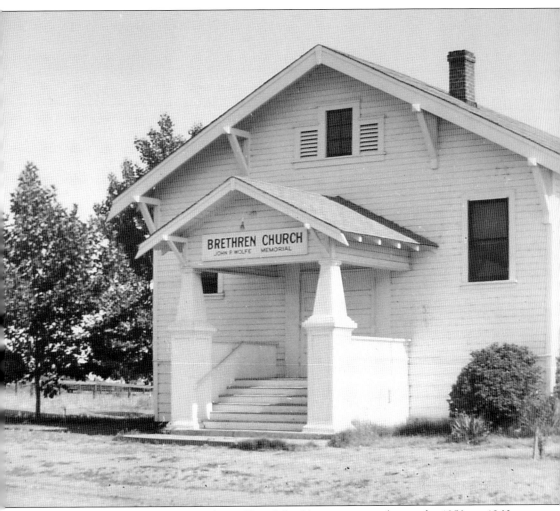

This photograph shows a newer Brethren Church building sometime during the 1950s or 1960s. Still standing since 1921 in the same location on the corner of J Street and Fifth Street, the building has experienced some exterior changes and additions. Having burned down twice since the original construction, the church has been rebuilt both times in the same fashion as the first. George Wolfe was the founding elder of this congregation in Lathrop, and Felix Senger served as minister. Jacob Wolfe and Henry Haines acted as deacons. During those early days, the congregation did not have their own place to meet, and in 1878 the founding members met in the second story of the Lathrop schoolhouse. The schoolhouse was across the street from where the church now stands. (Courtesy of Mac Freeman.)

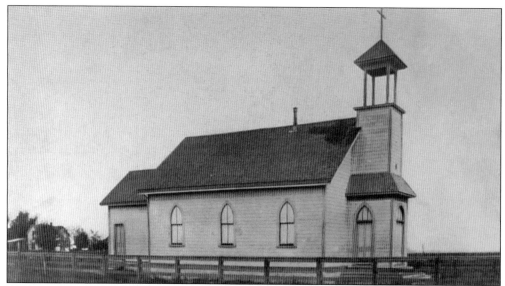

Lathrop's first Catholic church was located at the northwest edge of town on the corner of I and Seventh Streets. Serving the community from its founding in May 1877 to around 1928, the church was never dedicated nor given an official name. It was a mission of Stockton's St. Mary's church. Rev. W. B. O'Connor was the pastor, and church met the third Sunday of the month. (Courtesy of Mac Freeman.)

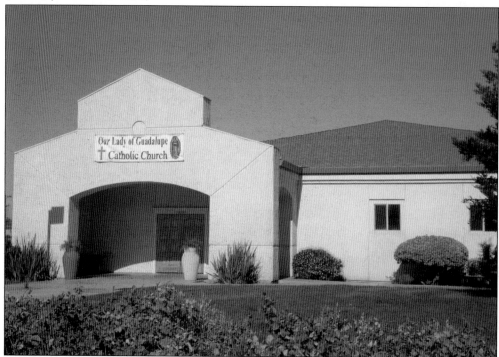

Our Lady of Guadalupe Catholic Church was officially dedicated as a parish on December 12, 2002. The parish's first pastor was Fr. Dean McFalls. Many families attend and serve the church today. Programs offered by the parish include religious education classes, Bible study, sacramental preparation, and an after-school study hall for children. (Author's collection.)

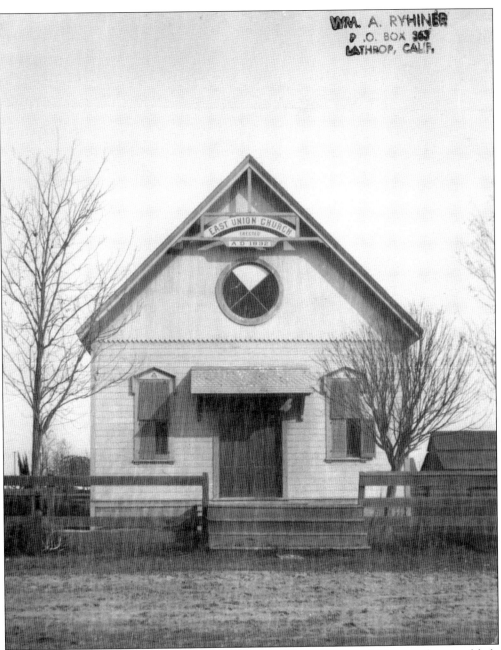

East Union Church was actually located in the neighboring town of Manteca but was likely frequented by residents of Lathrop as well. The church was on the corner of Louise Avenue and Union Road. The location once held by the church is now occupied by a Quik Stop Market. Also in place on the corner is a stone monument telling the history of the location and the church. East Union Church burned down in July 1937, and while nothing is left of the church, East Union Cemetery continues to occupy the southwest corner of this intersection. A landmark of San Joaquin County, the cemetery dates back to 1872. Many of Lathrop's earliest pioneers make their final resting place at East Union Cemetery. The Lathrop pioneers interred there include members of the Wolfe, Howland, Salmon, Elliott, and Southwell families. (Courtesy of Mac Freeman.)

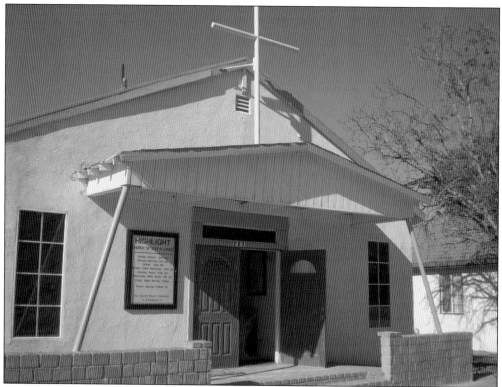

Highlight Church of God in Christ was started in the early 1960s by Maurice Cotton. The church on Lathrop Road has always been a family-run congregation. His son and other family members have taken over in recent years, as Cotton is unable to lead the church himself. Cotton family members are good-hearted people who are well respected in their community. (Author's collection.)

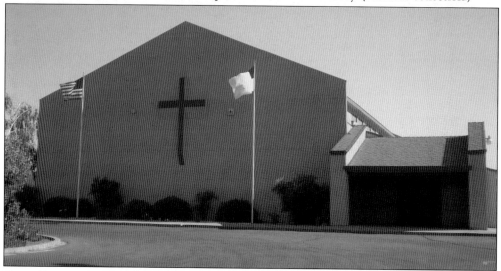

Grace Community Church was built mostly by its members. Construction began in 1981 and was completed in December 1985. With a large building to accommodate the church members and a lovely expanse of grass surrounding it, the family of Grace Community Church has established good, stable roots in Lathrop. (Author's collection.)

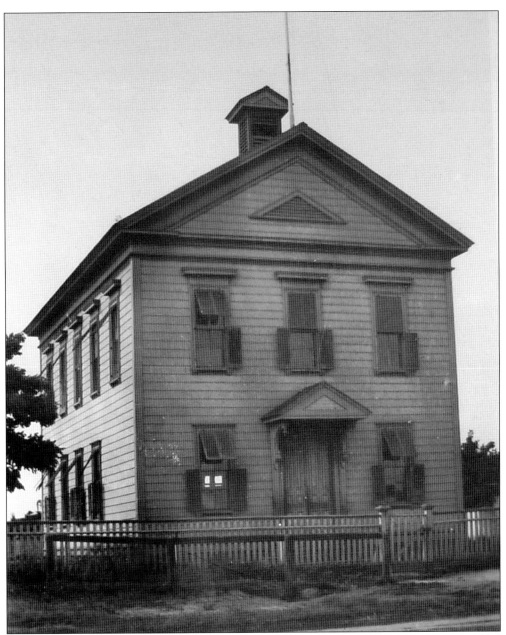

Lathrop schoolhouse was originally built in 1855. At the time of its construction, it was called Tulare School. When it was first built and opened for lessons, the schoolhouse was on the land where the Simplot factory stands now. The land was donated for this purpose by H. S. Howland, who owned and ranched on land in that area. The first teacher of the Tulare school was a Miss Howland, likely a daughter of H. S. Howland. In 1875, the school was dismantled and moved on wagons to a new location on the corner of J and Fifth Streets across J Street from where the Brethren Church would later stand. After this move, it was renamed Lathrop school. Out on the open land, the wind whistled through the school building and rattled the windows in their frames. Students may have walked or rode a horse to school or perhaps got a ride in a wagon, as the school was a bit of a distance from town. (Courtesy of Mac Freeman.)

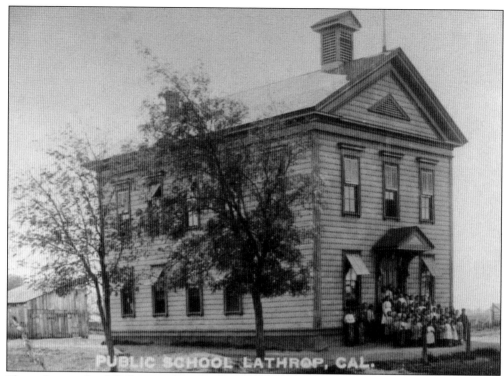

Shown here with a full class standing out front of the public schoolhouse, it was frequently closed for a day or two due to sand storms. All the open land surrounding the school made for very dusty conditions, and the Central Valley wind would stir up dust storms. (Courtesy of Mac Freeman.)

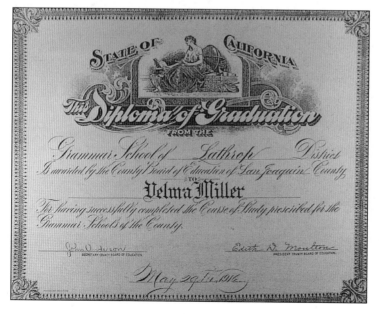

This is a copy of the ornate diploma of Velma Miller from Lathrop Grammar School. She graduated on May 29, 1916. Miller was the daughter of W. H. Miller and Wilma Clara Wilcox Miller, both upstanding, prominent Lathrop residents. She followed in their footsteps and as an adult was very involved in Lathrop schools and the community. (Courtesy of Mac Freeman.)

80

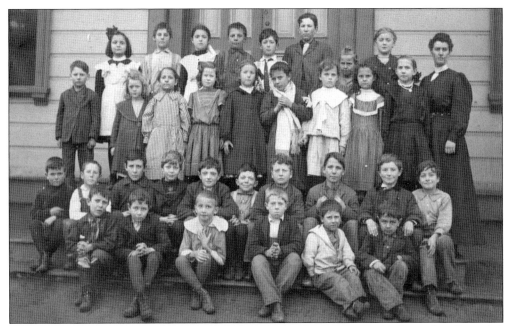

Here is a Lathrop School class photograph from between 1907 and 1909. Jessie Orr (far right) was the teacher. The picture belonged to Orr, who eventually lived in Lodi, and it was given to M. Hill by Margaret Merkel on February 19, 1964. Merkel was Orr's sister. (Courtesy of San Joaquin County Historical Society and Museum.)

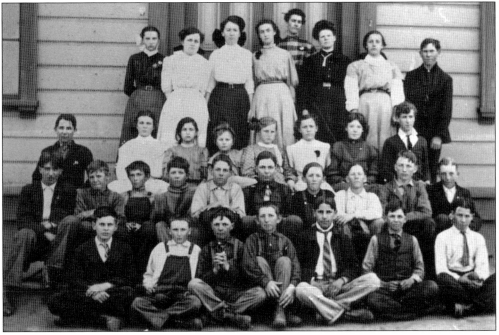

Orr poses here with her class in the early 1900s. She is standing at the top of the group in a checkered blouse. As was typical of schoolhouses at this time, all grades were represented here. Girls wore long skirts and blouses or dresses. Boys donned overalls or a jacket and tie, as several young men are wearing. (Courtesy of San Joaquin County Historical Society and Museum.)

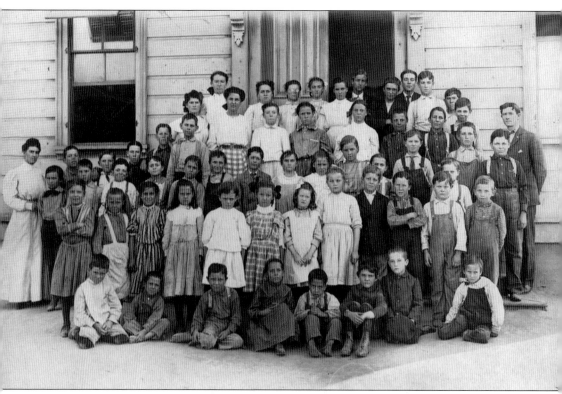

The two Lathrop teachers of this large class of 58 were Kenneth Ferguson, standing at the far right behind the boy in white suspenders, and Jessie Orr, on the far left in a white dress. They must have had their hands full trying to conduct lessons for so many children. The clapboard schoolhouse behind them has some of its windows open, as it probably got somewhat stuffy with so many bodies in one schoolroom. The children's clothing is typical of the time period of the early 1900s and was most likely sewn at home by female relatives. The majority of the girls have ribbons tied in their hair, which also was a typical fashion of the day. There are a few boys in the front of the group who are barefoot. Standing next to Orr is a boy with a darling bowtie who is looking a little bit shy. (Courtesy of San Joaquin County Historical Society and Museum.)

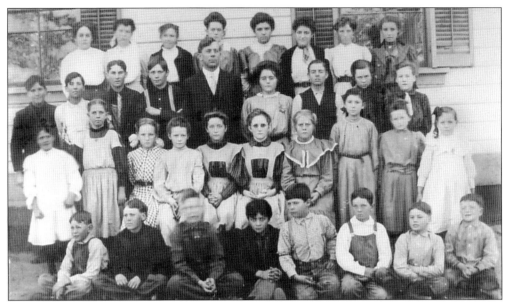

This Lathrop School photograph was taken around 1906. The teacher is proudly seated in the second row from the top surrounded by his students. The last little girl in the second row is Velma Miller. The young man sitting in the front row, third from left, must have moved as the picture was taken. His photograph came out blurry. (Courtesy of Mac Freeman.)

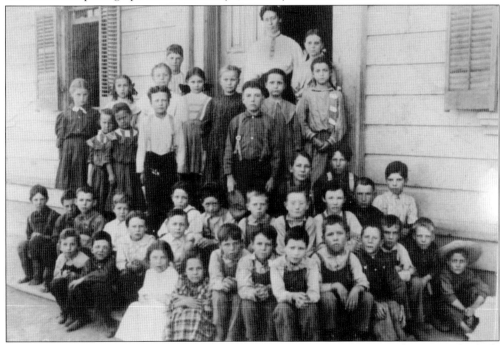

The Lathrop School pupils are seen here with Orr, their teacher, in the early 1900s. The little girls to the left with matching dresses were likely sisters. There are a few boys in front without shoes. They may not have owned a pair, or they may have saved them for colder weather. The young lad at the far right looks ready for an afternoon of sun in his floppy straw hat. (Courtesy of Mac Freeman.)

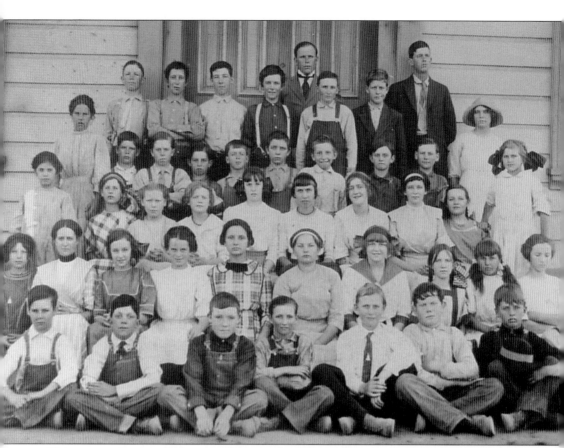

This stern and serious-looking teacher poses with his students on the front step of the Lathrop schoolhouse in 1911. Velma Miller is the young girl on the far right seated in the third row. As an adult, Miller continued to have an active role in the education system of Lathrop and served as an advocate and supporter rather than student. Several girls are wearing large hair ribbons. That would have been very stylish for the day. The number of pupils in this class is large for the one teacher, but with only one schoolhouse, everyone attended together. The children appear to be students of higher grades, perhaps third or fourth grade and up. In the warm months, the windows were thrown open, hoping to catch a breeze. During the winter, the teacher lit the woodstove every morning and kept it going during school hours to provide warmth for the schoolroom. (Courtesy of Mac Freeman.)

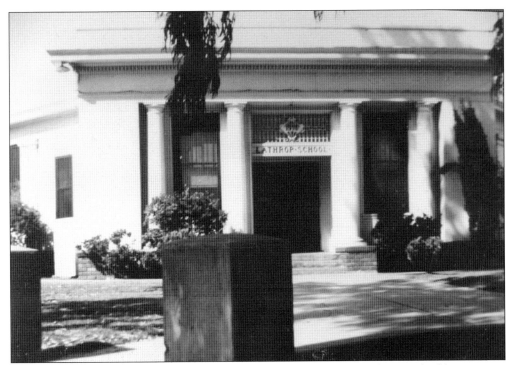

In 1916, construction was completed on the new Lathrop School. The new building was on the corner of Fifth Street and Thomsen Road. This building replaced the school located on J Street. At the time of its opening, the school had around 50 students and less than two teachers. (Courtesy of Mac Freeman.)

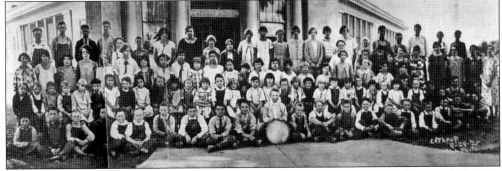

The whole student body poses outside of the Lathrop School on September 29, 1925. This photograph shows the unique corner entrance to the Lathrop School seen behind the students. One wing went down along Thomsen Road and another went down Fifth Street. (Courtesy of Mac Freeman.)

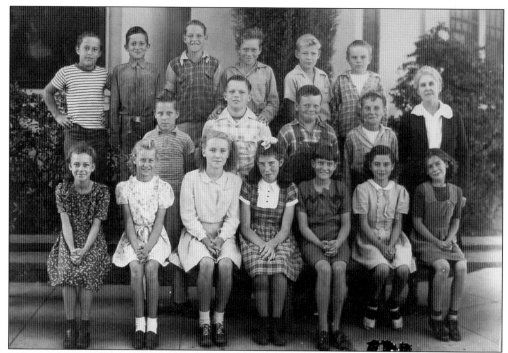

Taken around 1943 or 1944, this photograph shows a kind-looking teacher and her happy class sitting in front of the Lathrop School building that was constructed in 1916. These students look as if they were in about third or fourth grade. They are looking sharp and ready to learn. (Courtesy of Mac Freeman.)

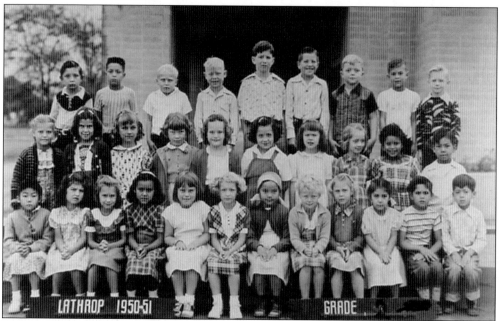

Here is a second-grade class from Lathrop School in the 1950–1951 school year. At recess, they may have been found playing marbles or jacks, jump rope, or kick the can. Some students may have also enjoyed games of dodgeball or tag around the playground. (Courtesy of Mac Freeman.)

Lathrop School was again rebuilt in 1952. In this photograph, Henry Gerlach holds a trowel of mortar as he is getting ready to lay the cornerstone for the building. Everyone present that day is all dressed up in their very best clothes for the occasion. (Courtesy of Mac Freeman.)

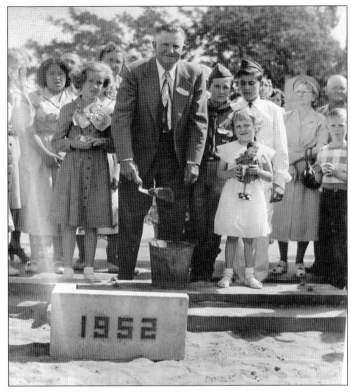

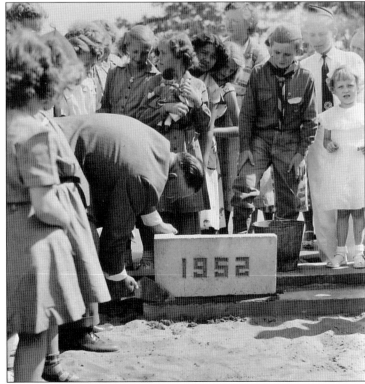

Here Henry Gerlach is placing the cornerstone for the new Lathrop School. The young boy in the Boy Scout uniform is Raymond Tinnin. The little girl on the far right in the white dress is Yvonne Miller. Miller was school queen that year. (Courtesy of Roy Tinnin.)

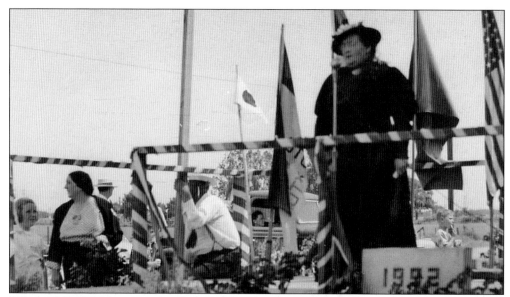

Velma Miller-McMurray said a few words to the crowd at the dedication of the new school. McMurray was a proud and prominent citizen of Lathrop. She served on the school board and was the organizer of the Old Timers Reunion, an annual gathering for those who have gone through Lathrop's schools. She was truly a pillar of this community in so many ways. (Courtesy of Mac Freeman.)

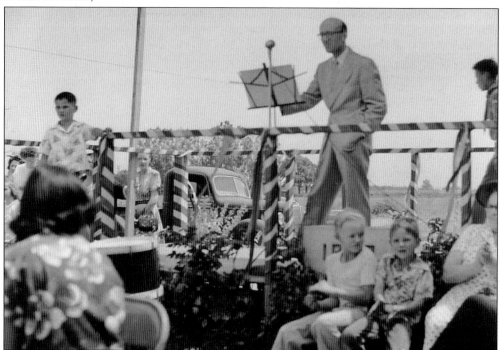

Stepping up to the podium on the well-decorated stage is Victor Marquis. He is getting ready to speak at the new Lathrop School's dedication ceremony. The women and children are getting ready to listen to the next part of the festivities. Marquis and his wife were highly involved with the school community in Lathrop. (Courtesy of Mac Freeman.)

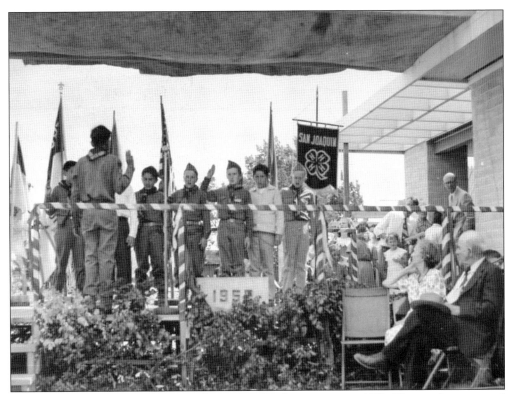

The local Boy Scouts are giving a pledge at the school's ceremony in 1952. The gentleman seated in the right-hand corner is Ben Armstrong. Armstrong owned 10 acres of land around Thomsen Road and Harlan Road. The land eventually went to his niece and is now developed. (Courtesy of Mac Freeman.)

The adorable little girls on stage also had a part in the dedication ceremonies that day. They were all dressed up, complete with hair ribbons, a bonnet, and favorite doll. With all eyes on them and assistance from the woman next to them, the girls were ready to do their routine. (Courtesy of Mac Freeman.)

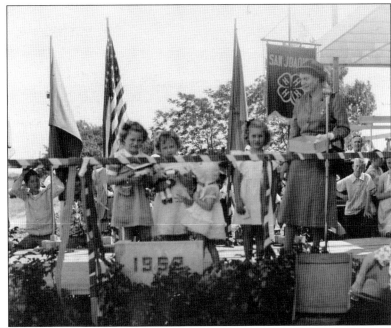

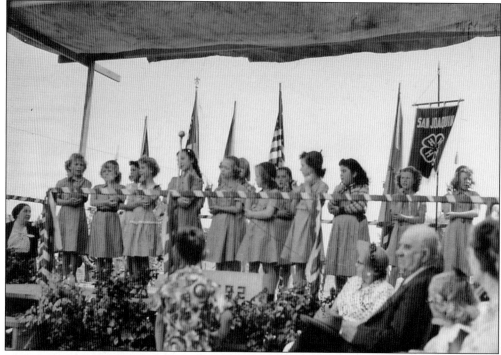

This group of Brownie Scouts is participating in the festivities for the dedication of the new Lathrop School by performing a song or pledge. The event warranted much fanfare and ceremony for the all in the community, as it provided new space and more resources for educating the youth in Lathrop. (Courtesy of Mac Freeman.)

Three teachers of Lathrop School pose in the school's courtyard. From left to right are Kenneth Culver, Helen Grinrod, and Jennie Canady. Although they are no longer teachers at Lathrop School, these educators are fondly remembered by members of the community. (Courtesy of Mac Freeman.)

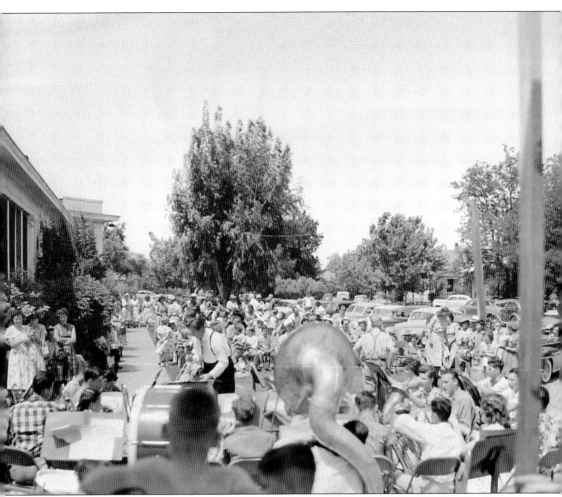

The majority of the community had come out for the dedication ceremonies of the new Lathrop School. There was much support for the new school, and that support continues with the schools in place today. Here is the well-dressed crowd on the Fifth Street side of the school building, getting seated and ready to listen to a band concert. The band is seated in the foreground with their instruments in hand. As the band is tuning up their instruments and getting the sheet music ready, the ladies, gentleman, and children in the crowd are hunting to find their seats. Quite a crowd has turned out for this event. There is no room left in the street for cars, and the seating areas on the lawns are full as well. (Courtesy of Mac Freeman.)

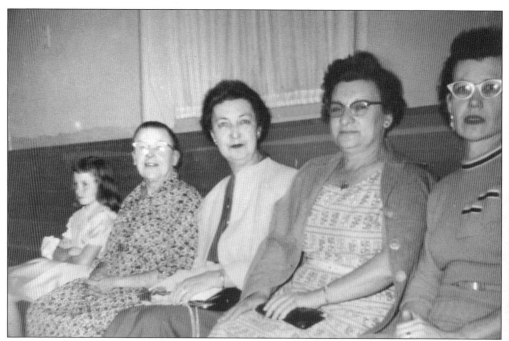

The little girl on the end looks bored as she sits with the four adult ladies. Ethel Allen sits in the middle in the white cardigan sweater, third from left. Mrs. Canady sits directly to the right of her. Canady was a sixth-grade teacher at Lathrop School. (Courtesy of Mac Freeman.)

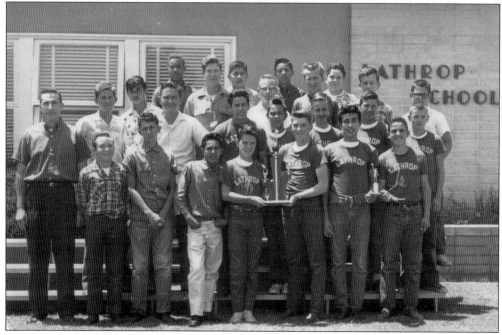

The 1961 Lathrop School baseball team stand on risers in front of the School. The two boys in the front center got the privilege of proudly holding up the team's trophy. The two boys to their right are lifting up a smaller trophy to be seen. The team's coach stands to the far left. (Courtesy of David Silveira, Lathrop School.)

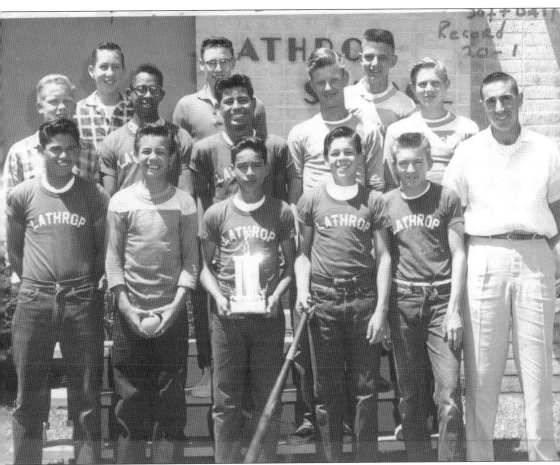

The boys and coach of the Lathrop School softball team stand in front of the school in May 1960; at the time this photograph was taken, the school had been open for eight years. The brick facade of the building remains unchanged; however, the school sign has been updated for a more modern look. The team had a record season that year with 20 wins and just one loss. It remains the best season record in school history. They happily stand with the ball, a bat, and their well-deserved trophy. Notice that the team uniforms consisted of jeans and a T-shirt, a very different look from the uniforms used today. The very neat haircuts sported by the players are another example of how the times have changed. (Courtesy of David Silveira, Lathrop School.)

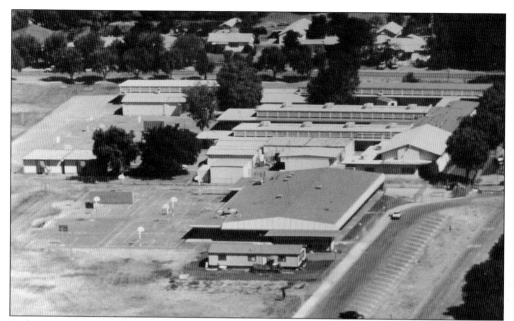

Lathrop resident Mac Freeman took this aerial view of the Lathrop School, built in 1952. The parking lot to the right is along Fifth Street, and running from left to right at the top of the photograph is Thomsen Road. On the school yard are several basketball courts for recess and physical education. (Courtesy of Mac Freeman.)

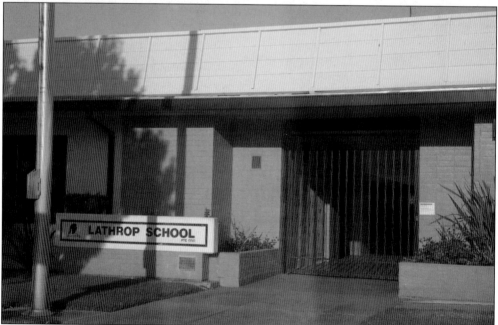

The present Lathrop School is the fourth building to carry the name. The first sat just outside of town near Howland Road, the second was located in town on the corner of Fifth and J Streets, and the third school was built on Thomsen Road and Fifth Street but was replaced by the current structure in 1952. Lathrop School continues to educate generations of families and will for many years to come. (Author's collection.)

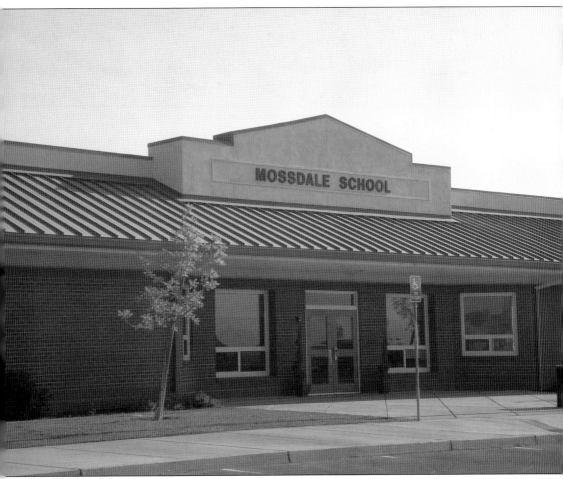

Mossdale School is the newest elementary school in the district, built as part of the planned community project on the west side of Interstate 5. Originally a second elementary school was planned for a location about a dozen blocks north of this school. While the sign remains announcing that a field on the west side of McKee Road will have a future school, plans to build this school were dropped when the construction of new houses was curtailed due to the economic downturn in 2007. Dedicated on October 24, 2007, this school serves all the Mossdale Landing neighborhoods of Lathrop, including those that were to be served by the unbuilt school. It was named after the original Mossdale School, which opened in September 1898. This first school was located one mile west of the current site, just east of Interstate 5. (Author's collection.)

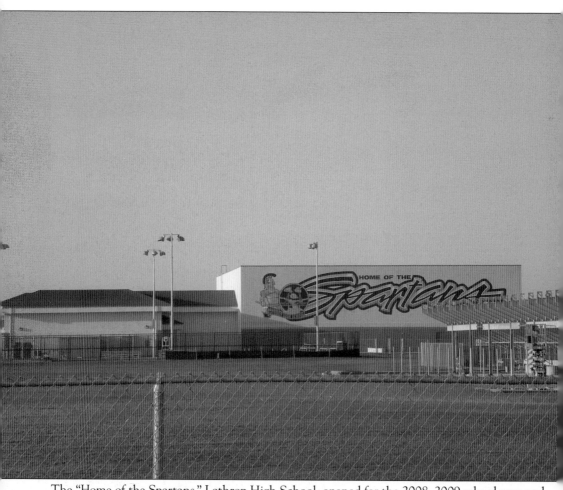

The "Home of the Spartans," Lathrop High School, opened for the 2008–2009 school year and is off to a good start. A much-awaited addition to the schools in Lathrop, the new high school is on Lathrop Road and is the sole high school in town. The high school suffered the impacts of the curtailment of the planned community project as well. Contractors who were abandoning their housing projects because they could no longer sell houses failed to complete many of the projects they had pledged to support the school. It was only at the start of the new school year that work was finally completed to open Lathrop Road connecting to the school. During the initial school year, the only usable entrance to the school was on Dos Reis Road, which prompted many safety complaints by the local residents. The city council is also trying to find the funds to complete the remainder of the sewage project for the school. Presently sewage must be expensively trucked from the school to the nearest treatment plant. (Author's collection.)

Four

MODERN LATHROP

In the 1940s, Lathrop grew from its original size to encompass an area of over 5 square miles. World War II brought Permanente Metals to Lathrop, a producer of aircraft parts, and Sharpe Army Depot also was established. After the war, housing tracts were built, and Lathrop became an industrial hub when it became home to companies, including Best Fertilizer and Libby-Owens Ford, the latter of which produces automotive glass. Although residential growth slowed in the 1950s and 1960s, Lathrop began to grow steadily once again in the 1970s and 1980s. Interstate 5 was built in the late 1960s, connecting this San Francisco bedroom community to the bay area and any number of places throughout the state and beyond. This highway is a major thoroughfare for California and the West Coast, as it extends from Mexico to Canada. In the 1980s, Lathrop was the fastest growing community in the county, and on July 1, 1989, it was incorporated. Lathrop has come a long way from the little community of 600 mostly railroad employees in 1879. It is now a thriving city with a population of approximately 20,000 people. Residents enjoy the rural feel of the area surrounded by fertile farmland, the beautiful San Joaquin River, and the California history.

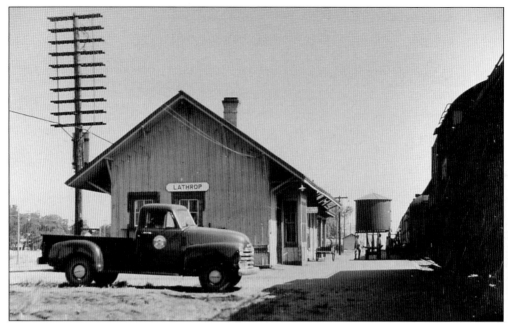

A train pulls into Lathrop depot in this photograph from the 1940s. Just below the water tank are depot employees and baggage carts lined up to help passengers and unload the train. The train passengers might have been traveling south to Los Angeles, north to Sacramento, or east to points as far as Chicago or even New York. (Courtesy of Mac Freeman.)

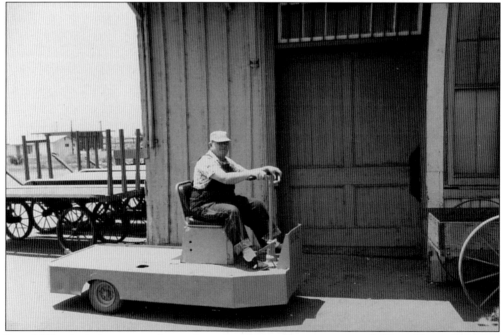

Ivan Miller is sitting on an electric horse used to pull wagons around. The old wooden carts behind him at the end of the depot would have been used to take mail and baggage between the trains, making this chore much easier. The photograph was taken by Roy Tinnin around 1960. (Courtesy of Mac Freeman.)

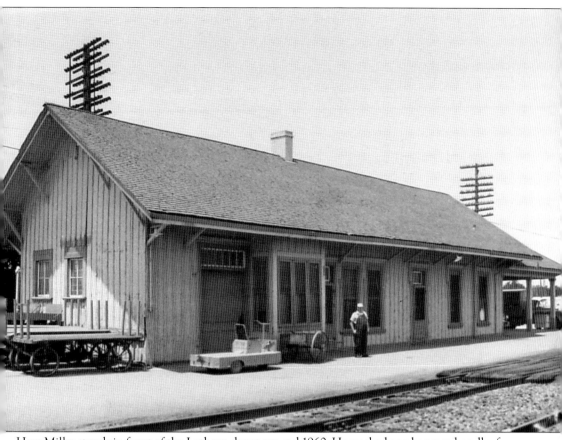

Here Miller stands in front of the Lathrop depot around 1960. He worked as a baggage handler for the Southern Pacific Railroad. Originally the depot did not have a protected area for passengers and baggage. A covered porch was added to the north end of the building at some point. (Courtesy of Roy Tinnin.)

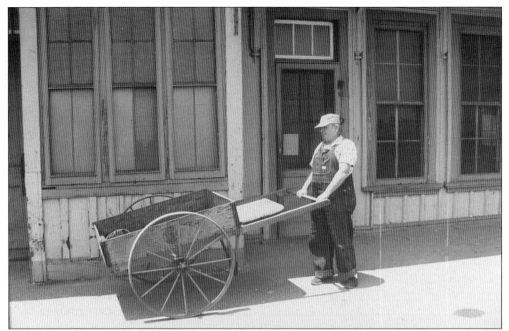

Ivan Miller poses with an old wooden handcart in front of the old depot building, which looks abandoned in this photograph. At one time, that handcart would have been used to move baggage and mail between trains. (Courtesy of Roy Tinnin.)

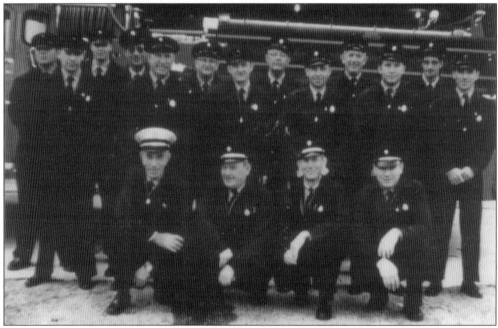

Lathrop's volunteer firemen are pictured in their new uniforms in the early 1960s. From left to right are (first row) Mike Spino, Ivan Miller, Carol Colvin, Richard Richich; (second row) Larry Fuller, Donald Mullins, Bill Hubble, Bill Pirtle, Lyle Percival, James Lowry, Charlie Hubble, Russ Bartenhagen, Kenneth Mullins, Francis Wiggins, Ralph Kullman, Henry Nasimento, and Bennie Gatto. (Courtesy of Mac Freeman.)

Tokyo Joe's was a gasoline station, market, and café located on Harlan Road. Joe's Mini Mart sits on the site now. The new owner decided to keep Joe in the name of the mini-mart as well. The new establishment was also Joe's Travel Plaza for a while. (Courtesy of Mac Freeman.)

This is the inside of Tokyo Joe's cafe. Diane Takeshita-Hirata's daughter Rhonda Hirata is the baby seated on the table. Tokyo Joe's was a family run business owned by Diane's father, Joe Takeshita. The menu board is a glimpse into the past, with nothing added to it over the $2 mark. The most expensive item on the menu was a shrimp or roast beef dinner for $1.65. (Courtesy of Diane Hirata.)

Janet and Tom Wiggin, grandchildren of Francis Wiggin Sr., sit in front of Wiggins Trading Post in 1949. Wiggin opened the store in 1924 on Harlan Road. Using his skills from his days with Buffalo Bill's Wild West Show, Wiggin sold Native American souvenirs along with gasoline and other goods. Although closed since 1967, a plaque stands to commemorate the trading post and the Lincoln Highway. (Courtesy of Gary Kinst.)

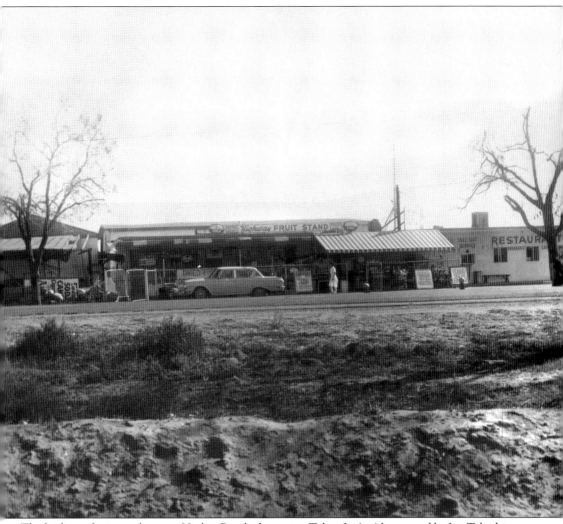

The highway fruit stand was on Harlan Road adjacent to Tokyo Joe's. Also owned by Joe Takeshita and his wife, Miyo, the stand was a one-stop shop, offering both groceries and pharmaceuticals. One could buy goods wholesale or retail, and there was a range of items available from fresh produce to frozen goods. (Courtesy of Diane Hirata.)

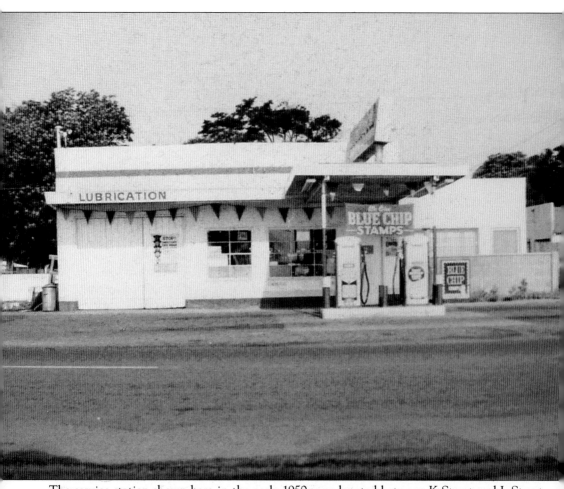

The service station shown here in the early 1950s was located between K Street and L Street on Seventh Street. Jim Langston owned the station. His wife, Bernelle, often worked there with him. The paved road is clearly visible here, but Lathrop's streets were not paved until the 1940s. (Courtesy of Mac Freeman.)

Among the shops along Seventh Street was this five-and-dime pictured during the 1950s. Following the lead of the original five-and-dime store opened by Frank Woolworth in 1879, these shops carried everything from toys to medicine. Most also had lunch counters complete with a soda fountain. The buildings seen here now house some businesses and a day care center. (Courtesy of Roy Tinnin.)

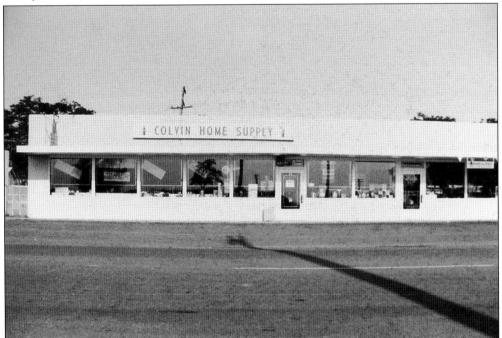

Here is Colvin Home Supply, which was located on Seventh Street. The building was constructed by Columbus Wilford during the 1950s, and it is quite different from the giant home improvement stores so popular today. Colvin's offered key-making services, seeds, paint, and other typical home supplies. The building is now home to Lathrop's police department. (Courtesy of Roy Tinnin.)

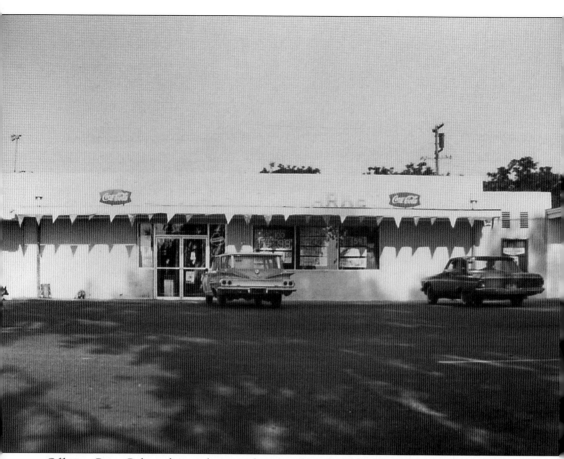

Offering Coca-Cola and specials on a selection of goods, Delta Market stood on Seventh Street between K and L Streets. Bicky Lum and his wife, May, opened this small market in the early 1960s. It was a local, friendly place where a person could cash their paycheck and buy their groceries; markets like this could be found in almost all small towns in America at that time. In the 1990s, Delta Market moved to a bigger, new locale on the corner of Fifth Street and Louise Avenue. Eventually this market building became Pena's Mercado store and now is Luis Super Mercado. The original Delta Market houses Living Word Ministries. Although Delta Market is a memory now that only the long-term Lathrop residents share, many members of the Lum family continue to call Lathrop home. (Courtesy of Roy Tinnin.)

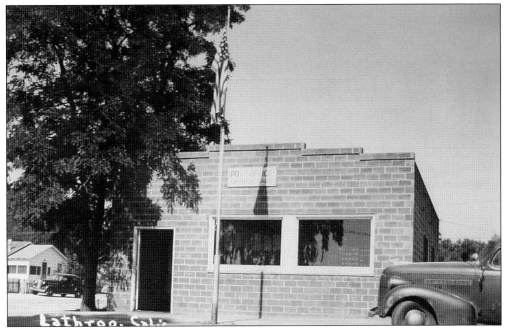

The brick Lathrop post office pictured here was built in the 1930s on the northwest corner of K and Seventh Streets. Today the building houses Tio Luis' Family Restaurant. Over the years, it has also been home to a hardware store and a barbershop. (Courtesy of Mac Freeman.)

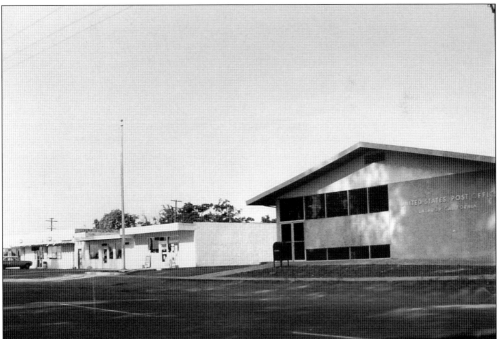

The current post office building was constructed across K Street from the older brick post office. While the buildings around it have changed some, the post office itself looks much the same today as it looks here. This photograph was taken in 1961 or 1962 by Roy Tinnin. (Courtesy of Mac Freeman.)

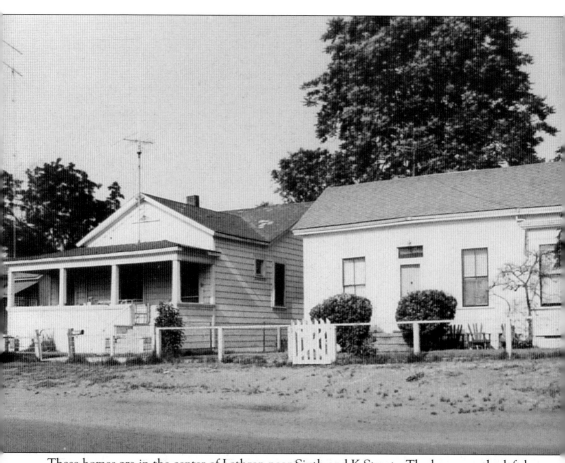

These homes are in the center of Lathrop near Sixth and K Streets. The house on the left has a spacious porch in front to visit with neighbors and relax with family. Approaching the home on the right, one is met by a charming, white picket gate and well-maintained bushes. (Courtesy of Mac Freeman.)

The lovely home seen here belongs to Artie and Juanita Elliott. The house is situated on Seventh Street south of O Street. With its bay window, many trees, and serene atmosphere, this is a house any family would be proud to come home to. The photograph was taken by Roy Tinnin in the 1960s. (Courtesy of Mac Freeman.)

Dell'Osso Family Farm was started in the 1920s by three brothers from Italy. The original crops were asparagus, but when one of the brothers, Rudy, took over the farm in the 1950s, he shifted into crops of tomatoes, beans, and alfalfa. The sign pictured is visible from Interstate 5 and Manthey Road and highlights the locale of the farm and pumpkin patch popular today. (Author's collection.)

This view is of the pumpkin patch and the brick silos at Dell'Osso Family Farm. The silos came with the land in the late 1920s. They were part of the farm and dairy built by Stewart Moore around 1918. In the 1970s, Rudy's son Ron Dell'Osso joined in the family farm and added melons, corn, and pumpkins to the crops. (Author's collection.)

Out on the farm are two members of the Dell'Osso family, uncle Ernesto and Michael, age four. Michael looks like he is enjoying this early taste of driving the tractor and working on the farm. This photograph was taken around 1957. In 1997, Ron and his wife, Susan, created the first corn maze at the Dell'Osso farm. Nearly 125,000 people visit each October. (Courtesy of Susan Dell'Osso.)

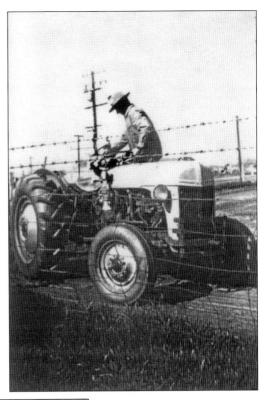

Hovering fairly low to the ground, Michael is once again the young boy seen here helping out with another farm task. In this 1956 photograph, he and the man with him are using the helicopter, from Stockton Helicopters, to spray the alfalfa crop. (Courtesy of Susan Dell'Osso.)

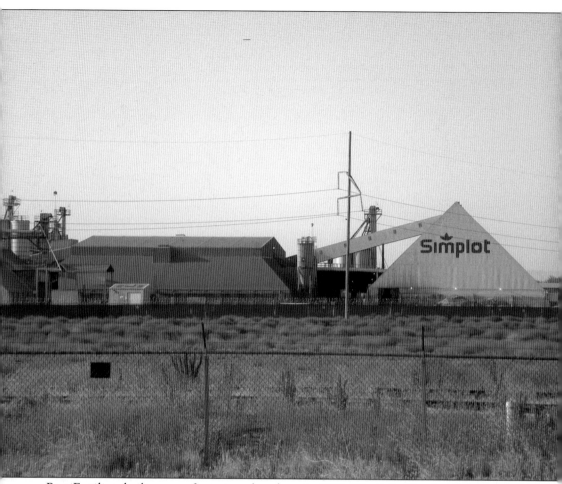

Best Fertilizer built a manufacturing plant here in 1953. The J. R. Simplot Company began operating it in 1983. In coordination with a plant in Helm, 130 miles southeast, the Lathrop facility makes nitrogen and phosphate fertilizer on Howland Road. Simplot's Lathrop plant is unique in the present day, running production with steam power created on site. While it was much more common to find plants and factories that generated their own power during the earlier parts of the 20th century, this is a practice that has been almost completely abandoned today. The Simplot plant remains in production and is a large employer of local residents, providing an important linchpin in the local economy. Sited next to the Pilkington-Nippon Sheet Glass factory, this industrial complex dominates the landscape south of Louise Avenue. (Author's collection.)

This smokestack of the Pilkington-Nippon Sheet Glass factory is a local landmark. Its red and white stripes can be seen from a distance away. Currently the plant makes float glass, which is so called due to the process of producing it. The process is to create large sheets by floating the glass on a bed of molten tin. This allows panels of glass to be formed that are perfectly flat and smooth. A second kiln is used after the glass is removed from the tin to allow it to be cooled gradually to avoid cracking from sudden changes in temperature. This glass is then made into automobile windshields and windows and sliding-glass patio doors by machines that cut the panels into sections of the appropriate size for the end product. This plant is also one of the major employers in the Lathrop area. (Author's collection.)

Libby-Owens Ford opened its doors here in Lathrop on Louise Avenue in June 1962. In 1964, production of float glass began. This was the second float glass plant in North America. Now owned by Pilkington-Nippon Sheet Glass, the furnace produces 600,000 square feet of glass each day it runs. (Author's collection.)

Fireside Cocktails was once the home of the Dos Reis family. Manuel Dos Reis came to Lathrop in 1921 and ran a dairy farm here for years. He and his wife, Anna, built a new house on the west side of Interstate 5 near Lathrop Road in 1926. They eventually sold the old house, and the building was moved to its current location on Lathrop Road and Fifth Street. (Author's collection.)

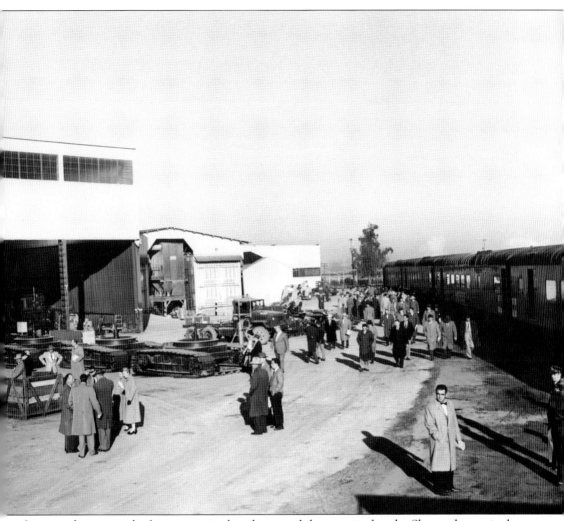

It seems the men and a few women in this photograph have arrived at the Sharpe depot via the train seen to the right. Tanks and other crates and equipment are visible in this view. At one time, the land held a sheep ranch, but in 1942, the Sharpe depot was officially dedicated as Lathrop Holding and Consignment Point. During the World War II, large volumes of equipment passed through this depot on the way to destinations in the Pacific Ocean. While no records have been found to document it, it is very likely that some of the equipment used in battle on islands like Iwo Jima, Guadalcanal, and Tarawa—as well as many other places—moved through here. While the depot is still in operation today, the scale of its operations are far smaller than at the time of this photograph. (Courtesy of the U.S. Army.)

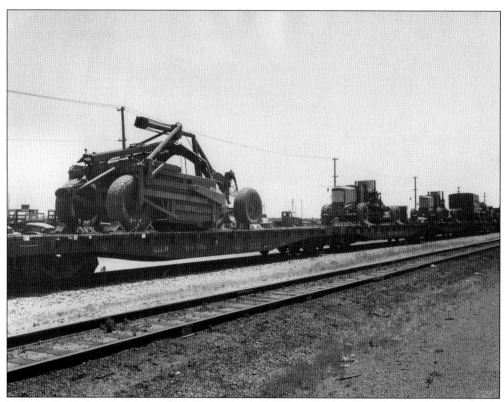

Vehicles and equipment are ready and waiting on a train at Sharpe Army Depot. During World War II, German and Italian prisoners of war were held at Sharpe. After World War II, the depot saw many changes, and in 1948, it was renamed Sharpe General Depot after Quartermaster Gen. Henry G. Sharpe. He was quartermaster general from 1905 to 1918. (Courtesy of the U.S. Army.)

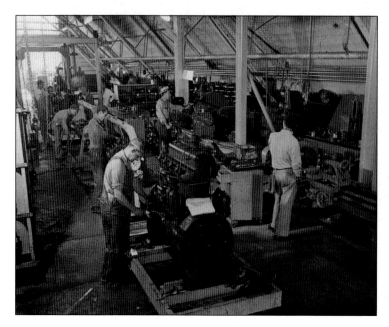

Mechanics work inside a machine shop at the Sharpe depot. The shop door stands open to allow in air and light, as these men toil over engines and various machinery. In 1962, the depot's name changed again when it was assigned to Army Supply and Maintenance Command. (Courtesy of San Joaquin Historical Society and Museum.)

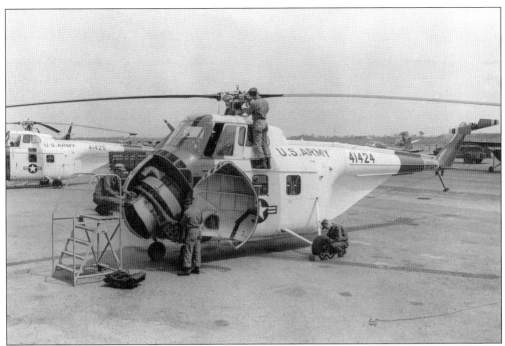

These Sharpe depot mechanics are repairing or maintaining this army helicopter. The depot served as headquarters of Defense Distribution Region West. It was one of 22 such centers. In 1999, the workload shifted from the Sharpe depot to the Tracy facility. As of that time, Sharpe was used to store slow moving, low demand, bulk items. (San Joaquin Historical Society and Museum.)

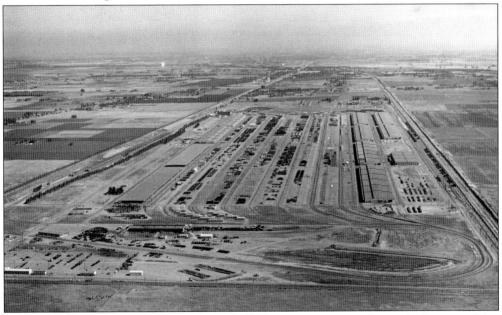

This picture shows an aerial view of the general annex quartermaster depot. At the time of this photograph, the depot had 2,700 employees and a civilian payroll of 12 million. The depot served as a transportation and supply center for the army. (Photograph by L. Covello Photos; courtesy of the San Joaquin Historical Society and Museum.)

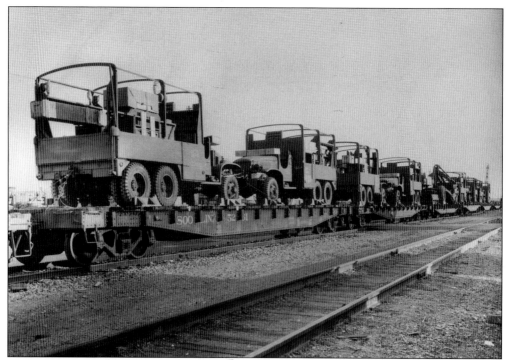

The army vehicles aboard these flat cars are ready to be transported at Sharpe Army Depot. They are tied on and set to be unloaded or shipped on to their destination. In 1965, the Sharpe depot became an important intermediary for supplies moving toward Southeast Asia during the conflict there. (San Joaquin Historical Society and Museum.)

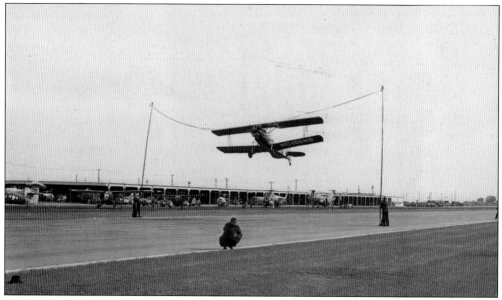

On October 13, 1960, the dedication of the Sharpe Army Airfield and the General of Armies John J. Pershing Hangar took place. A 1929 biplane is seen here cutting the ribbon across the airfield during the dedication ceremony. Loe Pfeifer of Pfeifer Aircraft Industries flew the biplane. (Courtesy of the U.S. Army.)

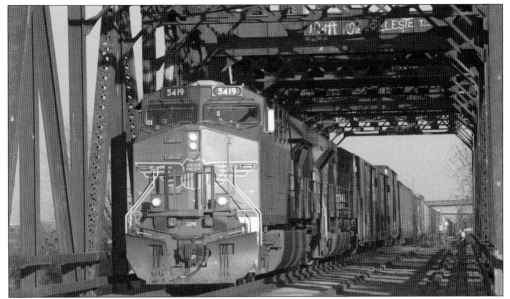

Trains still cross over the San Joaquin River at Mossdale 140 years after the first bridge was built there. The bridge that is present today was built in 1944. This photograph shows the Union Pacific Railroad's *Tracy Hauler*, as it travels on its way to Tracy. Photographer Chris Butts snapped this photograph on December 9, 2007. (Courtesy of Chris Butts.)

This aerial of Lathrop was taken by Lathrop resident Mac Freeman on August 19, 1989. Interstate 5 runs diagonally across the upper left corner. The Lathrop Community Center and Lathrop School make up the buildings in the center. At the right edge of the picture is the head of the railroad wye where it meets the tracks that run along Seventh Street. (Courtesy of Mac Freeman.)

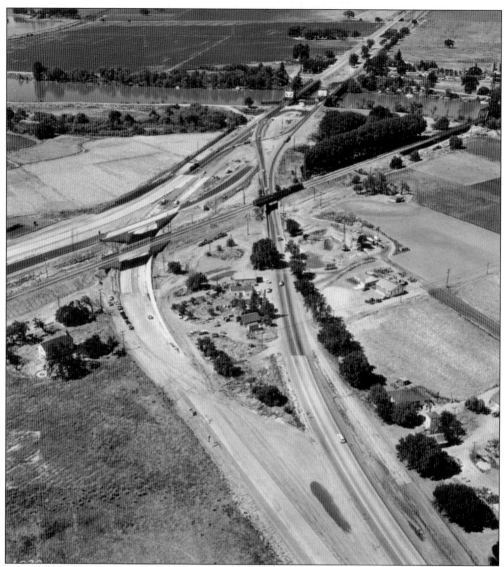

This wonderful shot shows all three bridges over the San Joaquin River at Mossdale. Taken on May 27, 1958, the view includes two automobile bridges in the upper portion, and in the upper right corner is one end of the railroad bridge. Above the railroad bridge is the Dell'Osso farm, visible among the trees. Below the roads on the left is the Mossdale School, which was built in 1898. The school was built up high to protect it from floods. While all three bridges are still in existence today, the two automobile bridges are lightly used on secondary roads now. The bulk of the automobile traffic is now carried on two modern spans that carry Interstate 5 across the river just east of the three bridges here. (Copyright © 1958 California Department of Transportation.)

The Lathrop Veteran's Memorial is "dedicated to all the veterans that served in each of the branches of the U.S. military. Honoring those that gave their lives for the freedom of our great nation." Those who are remembered as of August 2009 include George R. Calloway, Joseph Tafoya, David Angelo Alvarez, Donald Rieger, Gale Butcher Jr., Roscoe Carnes Jr., Brock Elliott, Michael Vega, Alvin Mendes, Charles White Sr., and James Joseph Chio. (Author's collection.)

The San Joaquin River runs gracefully through the area and remains a popular spot for boating and fishing. This portion of the river is located between Mossdale Regional Park and Dos Reis Regional Park. Both parks offer many amenities, including picnic areas, boat-launching facilities, and fishing access. The parks give residents of Lathrop and visitors a pleasant place to enjoy the San Joaquin River. (Author's collection.)

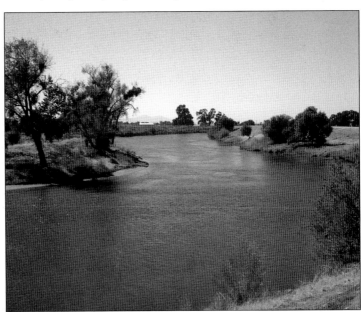

The Tower Mart gasoline station on Lathrop Road is a popular roadside attraction frequented by many travelers. The UFO sticking out of this local pit stop makes it a fun place for photographs. Green aliens grace the edge of the spacecraft, while inside, the rest of the UFO protrudes with a hole in its side as a result of its crash. Other aliens are placed around the market. (Author's collection.)

Located on Seventh Street, the Lathrop Branch Library is part of the San Joaquin County Library system. Although not a large library, it offers a variety of programs for the residents of Lathrop. Among the library's amenities are computer access, activities for children, computer classes, and books for all ages. Opened in April 2005, it was the first library branch to do so in San Joaquin County since 1979. (Author's collection.)

Lathrop's new city hall opened in July 2005. Located in the new Mossdale Landing housing development west of Interstate 5, the city hall building is a hub of activity and city business. City hall houses many offices, including those of the city attorney, community development, the city manager, the city clerk, and human resources. The city council uses space in the city hall for its meetings held twice a month. (Author's collection.)

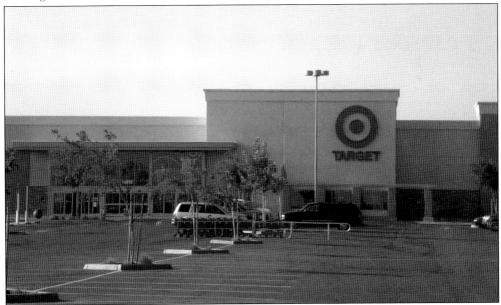

Located on Louise Avenue next to Interstate 5, Lathrop's Target store opened its doors in the summer of 2008. Besides the usual Target services, the Lathrop store includes a Pizza Hut Express counter and an in-store Starbucks. The store was a welcome addition to Lathrop's shopping amenities, as there are few other large stores in town. (Author's collection.)

Mossdale Landing is the newest housing development in Lathrop. With several parks, a place to walk along the river, a new school, and beautiful homes, the area is an ideal neighborhood for families and a great expansion for Lathrop. The new city hall building and a new fire station are also located in Mossdale Landing. (Author's collection.)

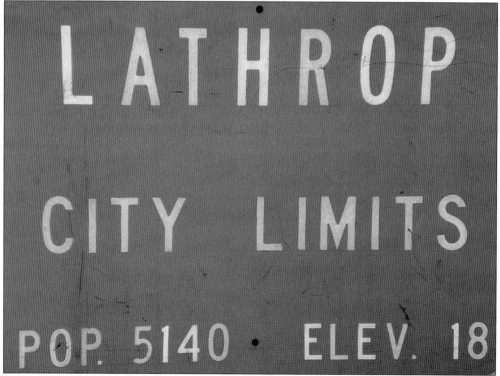

This is one of the first Lathrop city signs. It was replaced around the time the town was incorporated. Mac Freeman was able to buy the sign from the county for $30 in October 1989. It is signed on the back by the members of the first city council: Darlene Hill, Bennie Gatto, Apolinar Sangalan, Steven McKee, Mac Freeman, John Bingham, Sue Wilcox, and Carl Waggoner. (Author's collection.)

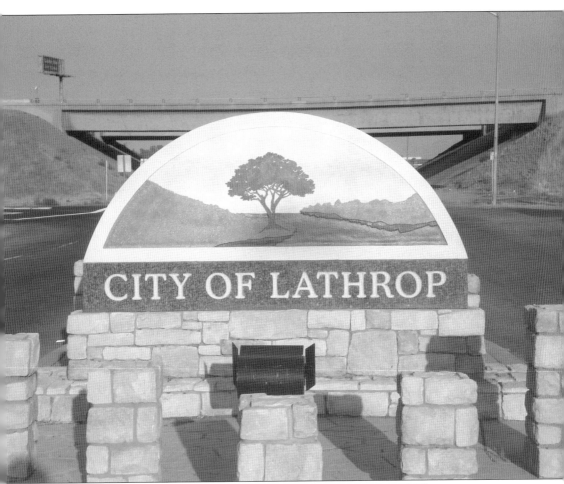

The city sign seen here is located just east of Interstate 5 on Lathrop Road. This attractive sign welcoming visitors and residents to Lathrop is a symbol of the honor with which the community has been embraced by its members. The graceful stone arch with its depiction of the San Joaquin River illustrates the plans and potential for growth of this small city. While the current economic climate has put many of the plans on hold at the present time, there is still a great deal of hope and optimism for the future of this community. The mayor and city council of this community remain committed to providing all the services embodied in the promise of this sign. Lathrop has moved beyond its origins as a railroad and agricultural center and today provides a home for a diverse population that is employed throughout the Bay Area. (Author's collection.)

Appendix A
Timeline

Before 1832 or 1833: Area is inhabited by the Yokut Native American tribe.

1828–1845: Trappers, hunters, and fishermen are in the Mossdale area of Lathrop.

1844: William Gulnac acquires this part of the valley as a grant from the Mexican government.

1845: Gulnac sells to Capt. Charles M. Weber the area just west of present-day Lathrop (called Weber Grant).

1849: John Doak and Jacob Bonsell establish the first ferry on the San Joaquin River at Mossdale.

1853: John Morrison buys 2,560 acres of land from Weber. The area is known as Wilson's Station.

1856: Doak and Bonsell sell ferry to William Moss.

1869: Leland Stanford changes the town name to Lathrop. On November 10, San Joaquin River bridge is completed, and the Transcontinental Railroad is completed.

1870: On May 22, the first train through from East Coast to San Francisco crosses the bridge.

1886: Fire burns most of Seventh Street, some of Sixth Street, the railroad depot, and the terminal.

1889: Former California Supreme Court justice David S. Terry is shot by U.S. Marshal David Neagle.

1891: The Southern Pacific Railroad constructs a new depot.

1942: The Sharpe depot is officially dedicated as Lathrop Holding and Reconsignment Point.

1948: The army depot is renamed Sharpe General Depot.

1970s: In the early 1970s, the Southern Pacific Railroad depot is removed.

1989: Lathrop is incorporated.

1990s: The Union Pacific Railroad builds an intermodal facility near the Sharpe depot.

2005: The new Lathrop City Hall is built.

APPENDIX B
BENJAMIN HARRISON'S
SPEECH

On April 25, 1891, Pres. Benjamin Harrison stopped in Lathrop while on a train tour around the country. Included here is a description of his visit and the speech he gave while at Lathrop from *Speeches of Benjamin Harrison, Twenty-third President of the United States*, compiled by Charles Hedges and published by the New York United States Book Company in 1892.

The president's arrival at Lathrop was celebrated by several thousand residents, reenforced by large delegations from the neighboring city of Stockton. The Committee of Reception consisted of James J. Sloan, A. Henry Stevens, Z. T. White, O. H. P. Bailey, E. Jesurun, T. B. Walker, W. S. Reyner, D. Sanguinite, Geo. H. Seay, O. D. Wilson, C. F. Sherburne, F. D. Simpson and F. J. Walker. The Committee of Reception appointed by the mayor of Stockton and participating on behalf of the city was J. K. Doak, F. J. Ryan, I. S. Haines and Willis Lynch, H. R. McNoble, J. M. Dormer, and F. T. Baldwin. A feature of the reception was 100 schoolchildren, each carrying a bouquet, which they presented to President and Mrs. Harrison, both of whom kissed several of the little donors. Postmaster Sloan delivered the welcoming address. The president, responded with the following speech:

> My fellow citizens—I should be less than human if I were not touched by the rapid succession of hearty greetings received by us in our journey through California. I should be more than human if I were able to say something new or interesting at each of these assemblies.
>
> My heart has but one language: it is, "I thank you."
>
> Most tenderly do I feel as an individual so much of this kindness as is personal to me, and as a public official I am most profoundly grateful that the American people so unitedly show their love and devotion to the Constitution and the flag.
>
> We have a Government of the majority; it is the original compact that when the majority has been fairly counted at the polls, the expressed will of that majority, taking the form of public law enacted by State Legislatures or the national Congress, shall be the sole rule of conduct of every loyal man. [cheers]
>
> We have no other king than law and he is entitled to the allegiance of every heart and bowed kneed of every citizen. [cries of "Good! Good!" and cheers]
>
> I cannot look forward with any human apprehension to any danger to our country, unless it approaches us through a corrupt ballot-box. [applause] Let us keep that spring pure and these happy valleys shall teem with an increasing population of happy citizens and our country shall find in an increasing population only increased unity and strength. [cheers]

DISCOVER THOUSANDS OF LOCAL HISTORY BOOKS FEATURING MILLIONS OF VINTAGE IMAGES

Arcadia Publishing, the leading local history publisher in the United States, is committed to making history accessible and meaningful through publishing books that celebrate and preserve the heritage of America's people and places.

Find more books like this at
www.arcadiapublishing.com

Search for your hometown history, your old stomping grounds, and even your favorite sports team.